Dedalus European Classics
General Editor: Mike Mitchell

The Life of Courage

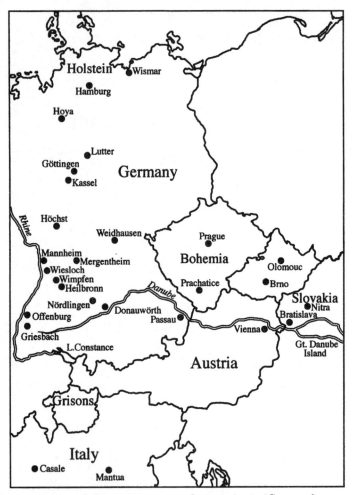

A map of the main towns and countries in 'Courage'.
The state boundaries are modern.

Johann Jakob Christoffel von Grimmelshausen

The Life of Courage: the notorious Thief, Whore and Vagabond

Translated with an introduction
and chronology by Mike Mitchell

Dedalus

Funded by
THE
ARTS
COUNCIL
OF ENGLAND

Published in the UK by Dedalus Ltd, Langford Lodge, St Judith's Lane, Sawtry, Cambs, PE28 5XE
email: DedalusLimited@compuserve.com

ISBN 1 873982 56 9

Dedalus is distributed in the United States by SCB Distributors, 15608 South New Century Drive, Gardena, California 90248
email: info@scbdistributors.com web site:www.scbdistributors.com

Dedalus is distributed in Australia & New Zealand by Peribo Pty Ltd, 58 Beaumont Road, Mount Kuring-gai N.S.W. 2080
email: peribo@bigpond.com

Dedalus is distributed in Canada by Marginal Distribution, Unit 102, 277 George Street North, Peterborough, Ontario, KJ9 3G9
email: marginal@marginalbook.com web site: www.marginal.com

Dedalus is distributed in Italy by Apeiron Editoria & Distribuzione, Localita Pantano, 00060 Sant'Oreste (Roma)
email: apeironeditori@hotmail.com

First published by Dedalus in 2001
Translation copyright © Mike Mitchell 2001

Typeset by RefineCatch Ltd
Printed in Finland by WS Bookwell

THE TRANSLATOR

Mike Mitchell is one of Dedalus's editorial directors and is responsible for the Dedalus translation programme. His publications include *The Dedalus Book of Austrian Fantasy: the Meyrink Years 1890–1932*; *Harrap's German Grammar* and a study of Peter Hacks.

Mike Mitchell's translations include the novels of Gustav Meyrink and Herbert Rosendorfer, *The Great Bagarozy* by Helmut Krausser, *Simplicissimus* by Grimmelshausen and *The Road to Darkness* by Paul Leppin.

His translation of *Letters Back to Ancient China* by Herbert Rosendorfer won the 1998 Schlegel-Tieck German Translation Prize.

German Literature from Dedalus

Dedalus features German Literature in translation in its programme of contemporary and classic European fiction and in its anthologies.

Undine – Fouqué £6.99
The Life of Courage – Grimmelshausen £6.99
Simplicissimus – Grimmelshausen £10.99
The Great Bagarozy – Helmut Krausser £7.99
The Other Side – Alfred Kubin £9.99
The Road to Darkness – Paul Leppin £7.99
The Angel of the West Window – Gustav Meyrink £9.99
The Golem – Gustav Meyrink £6.99
The Green Face – Gustav Meyrink £7.99
The Opal (& other stories) – Gustav Meyrink £7.99
Walpurgisnacht – Gustav Meyrink £6.99
The White Dominican – Gustav Meyrink £6.99
The Architect of Ruins – Herbert Rosendorfer £8.99
Letters Back to Ancient China – Herbert Rosendorfer £9.99
Stephanie – Herbert Rosendorfer £7.99

Anthologies featuring German Literature in translation:
The Dedalus Book of Austrian Fantasy – editor M. Mitchell £10.99
The Dedalus Book of German Decadence – editor R. Furness £9.99
The Dedalus Book of Surrealism – editor M. Richardson £9.99
Myth of the World: Surrealism 2 – editor M. Richardson £9.99
The Dedalus Book of Medieval Literature – editor B. Murdoch £9.99

Forthcoming titles include:
The Dedalus Book of German Fantasy: the Romantic and Beyond – editor M. Raraty £10.99

Introduction

Grimmelshausen quickly followed up the success of *Simplicissimus* (1668, though dated 1669) with a number of other books to which he himself refers in the foreword to the last as the 'Simplician writings'. Probably the best of these – and certainly nowadays, since Brecht's appropriation of the heroine, the best-known – is *The Life of Courage, the Notorious Thief, Whore and Vagabond*, which appeared in 1670. All these books were published under elaborate anagrammatic pseudonyms (German Schleifheim von Sulsfort, Philarchus Grossus von Trommenheim, Michael Rechulin von Sehmsdorf) and the identity of Grimmelshausen as author was not established until 1835.

The Life of Courage is conceived as *A Counterblast to Simplicissimus*. Courage is the woman with whom Simplicissimus has an affair, then discards as a 'man-trap . . . whose easy virtue soon disgusted' him. Neither her name, nor the means by which he gets rid of her are mentioned in *Simplicissimus*, but his nasty and embarrassing trick is described in some detail in *Courage* and is part of the fictional motivation for her recounting her life story. She does it, she tells us, to shame Simplicissimus by showing the world what a depraved woman he boasted of having had an affair with. This allows Grimmelshausen to make his heroine give a frank confession of all her misdeeds: cheating, lying, stealing and, above all, fornication. The claim of a serious purpose in using her story as a

dire warning is really a piece of moral sticking plaster rather crudely applied in a note from the author at the end. The third of these 'Simplician writings', *Der seltzame Springinsfeld* (The strange life of Tearaway), starts with a meeting between Simplicissimus, Tearaway and 'the author' in which the latter tells how he met Courage and was conned into writing down her life story for her.

Courage is in many ways the female counterpart to Simplicissimus. Like him, she is swept away in the wars as a young innocent and like him makes her way through the devastation of war-torn Germany by using her considerable talents, in her case her beauty, a nimble and resourceful mind and an extremely elastic conscience. Unlike Simplicissimus, who becomes involved in the war as a boy only after the battle of Nördlingen in 1634, Courage goes through almost the whole thirty years, from the initial Bohemian campaign of 1619–1620 to the Peace of Westphalia in 1648.

As in *Simplicissimus*, Grimmelshausen again employs the device of the heroine's mysterious parentage which, of course, turns out to be aristocratic. Although her father is only referred to by initial, as Count T., a nobleman who 'had been the most powerful in the kingdom' but had been forced to flee to Istanbul because of his rebellion against the emperor, the reference is clearly to Mathias Thurn, the leader of the Bohemian rebels. This device is borrowed from the courtly romances which Grimmelshausen, and his Spanish models, parodied. It is interesting to note that he also wrote a courtly

10

novel himself, *Dietwalt und Amelinde*, perhaps, like Sullivan desperately trying to make his name as a composer of grand opera, in order to appear to the public as a respectably serious artist.

Courage's life is set against a real historical background, which Grimmelshausen emphasises by frequent reference to battles, sieges and campaigns, regiments, armies and generals. In her odyssey she covers almost the whole of the territory drawn into the German wars, from Slovakia in the east to the Rhine in the west, from Holstein in the north to Mantua in the south. This background is matched by the realism of the characterisation, realism not so much in the sense of detailed psychology as in the concentration on physical reality and an absence of idealistic motivation. Most of the men offer Courage violence (some getting more than they bargained for) and she is frequently raped; a particularly graphic episode, with deliberate humiliation, is in chapter 12. She, for her part, almost comes to expect this and is quite happy to use her attraction to gain money and power over men. She has seven husbands (or similar), numerous lovers and hundreds of customers for her services as a prostitute. She accepts the brutal facts of life in a brutal age and makes the most of them. One aspect that will perhaps strike the reader as modern is the way in which she insists on preserving her independence, especially in the financial and contractual arrangements she makes with some of the men she marries or otherwise lives with.

Courage tells her own story and the crude facts of her life are matched by a language which is vigorous

and earthy. Despite the occasional moral reflection the author obviously feels obliged to put into her mouth, Courage has a great capacity for enjoyment and is completely unrepentant. (The relationship between morality and entertainment is well put by Henry and Mary Garland in their comment on another of Grimmelshausen's books: 'The moral basis of the story is somewhat impaired by the gusto devoted to the description of obscene incidents.') As the first chapter makes clear, this is no old woman regretting the aberrations of youth, but one who has enjoyed life to the full and intends to go on doing so for as long as she can. To describe this she is not afraid of crude, down-to-earth expressions, but she also uses suggestive remarks, vivid images and even outrageous puns. The whole narrative throbs with the personality of its heroine.

Although Brecht, in *Mother Courage and her Children*, borrowed the name of Courage and the regimental canteen she runs for part of the book, that, together with the background of war and devastation, is really all the two works have in common. Grimmelshausen's Courage, for example, is barren and has no children. Whereas she often manages to come out on top, and always comes up smiling, Brecht's character is a rather grim survivor. This reflects the different purposes of the two authors. Grimmelshausen wants to entertain his readers and teach a moral lesson, Brecht intends the audience to derive a political message from his play. While both figures exploit circumstances whenever possible, Grimmelshausen's does so with zest, fully

aware that it is a dog-eat-dog world and determined to eat rather than be eaten. Brecht's Courage takes advantage of people where she can, but is unaware of what the audience (supposedly) sees, namely the contradiction that all her activities ultimately support a system which is so arranged that it is impossible for her to thrive. Zest, perhaps not surprisingly, is not a characteristic we associate with Mother Courage.

Chronology

As with Simplicissimus, *frequent reference to battles, generals and armies sets the fictional story of Courage against a real historical background. The following chronology records the main datable events in the novel to give a general indication of the time scheme against which the story is set.*

Summer 1620: 'When the Duke of Bavaria and General Buquoy marched into Bohemia to depose the Winter King, I was a pert young girl of thirteen . . .'

8 November 1620: 'I wished I were a man so I could spend my whole life making war. And this desire was only increased by the Battle of the White Mountain . . .'

Spring 1621: 'In the meantime we had entered the Hungarian province of Slovakia ... and taken Bratislava.'

10 July 1621: '. . . but at Nitra we suffered a reverse in the course of which not only did my captain receive a fatal wound, but our General, Count Buquoy himself, was killed.'

27 April 1622: '. . . for my captain was shot dead at Wiesloch . . .'

6 May 1622: 'In that pleasant, not to say lively encounter at Wimpfen . . .'

2 July 1622: 'I carried on this way until we defeated the Duke of Brunswick at Höchst . . .'

29 August 1622: '. . . the Count of Anhalt defeated Mansfeld and the Duke of Brunswick again, this time at Fleurus . . . my runaway husband was captured, recognised as a deserter and strung up from the nearest tree . . .'

27 August 1626: '. . . it was the second day after we had joined with Tilly that we came up against the King of Denmark at Lutter.'

12 December 1626: '. . . while I was leaving Hoya, tearful and downcast, with our men, who had surrendered for fear the castle might collapse on top of them . . .'

Summer/autumn 1627: 'It was at about this time that Wallenstein, Tilly and Count Schlick overran Holstein and other Danish territories . . .'

May 1629: 'We were soon out of the wood and that evening reached the musketeer's regiment, which was preparing to set out for Italy with the forces of Collalto, Altringer and Gallas.'

Autumn 1629: 'But at a time when our army was marching at full speed for Italy and had to force its way through Grisons, not many

sensible officers were thinking of looking for a wife . . .'

Winter 1629/30: 'After the first siege of Mantua we went into winter quarters in a lively little town . . .'

18 July 1630: 'Shortly before the imperial army took Mantua . . .'

29 August 1631: '. . . peace itself broke out between the Empire and the French, just as if our clash had signalled the end of the Italian campaign.'

4 May 1632: 'I stuck it out there until I heard that Wallenstein had captured Prague . . .'

16 May 1634: 'I had hardly settled down and started to enjoy all the money I had amassed when the Saxons under Arnim defeated the imperial forces at Liegnitz.'

5/6 September 1634: '. . . the imperial army was now besieging Nördlingen and a bloody battle ensued, the course of which will never be forgotten.'

1644: 'At that time there were no imperial troops anywhere near that I could join.'

5 May 1645: 'Now that I and my baggage were carried I found the life more bearable and put up with it until the beginning of May, when Mercy dealt us some telling blows at Mergentheim.'

24 October 1648 (Peace of Westphalia): 'Not only did I and my mule remain with the army until the peace treaty was concluded, I stayed with the gypsies even after peace had been established.'

Chapter 1

A very necessary explanation of the reasons why the old swindler, vagrant and gypsy Courage felt impelled to recount her truly strange and remarkable life and to whom the account is addressed.

'What?!' I can hear you gentlemen say. 'Who would have thought the old bag would have the cheek to try and escape God's wrath on the Day of Judgment? But needs must when the devil drives, I suppose. Her youthful frolics are over, her wanton high spirits have evaporated, her anxious conscience has woken and she has reached that sour-faced age which is ashamed to continue its foolish excesses and feels disgust at the idea of keeping all her previous misdeeds locked up inside her. It has begun to dawn on the old reprobate that death is sure to come knocking at her door soon to collect her last breath and send her off to another world, where she will have to account for all her actions here on earth. That's why she's starting to unload her poor pack-horse of a soul of its heavy burden in full public view. She's hoping she can relieve it of enough to qualify for divine grace after all.'

Yes, my dear sirs, that's what you will say. And others will think, 'Does Courage imagine that after all the things she's done to her old, raddled skin to give it a different colour – smearing it with French lotions for the scab in her youth, then with all kinds of Italian and Spanish creams, and finally plastering

19

it with gypsy louse-repellents and pounds of goose-fat, smoking it black at the camp fire – does she imagine she can make it white again? Does she think she can remove the deep-ploughed furrows from her dissolute brow and restore it to the pristine smoothness of her innocence by relating her vices and villainies? Does she think she can clear out her conscience so easily? Does this old hag,' I can hear you say, 'who already has both feet in the grave – if she deserves a grave at all – , who has spent her life wallowing in all kinds of wickedness and debauchery, with more misdeeds than years, more acts of fornication than months, more thefts than weeks, more mortal sins than days and more venial sins than hours, who has never given a thought to mending her ways in all these years, does this old crone,' you will say, 'have the effrontery to presume she can make her peace with God? Does she suppose, now that her conscience is already inflicting more hellish torment on her than all the carnal pleasure she enjoyed during her life, she can still make things right? Perhaps if this useless, decrepit lump of clay had not wallowed in iniquity of the worst kind as well as the aforementioned carnal delights, if she had not sunk to the lowest depths of evil, she might be vouchsafed a glimmer of hope.'

Yes, gentlemen, that is what you will say, that is what you will think, such will be your astonishment when the news of my general and public confession reaches you. And when I hear of your reaction I will forget my age and laugh fit to burst, or perhaps even to make myself young again.

'Why, Courage? Why will you laugh so much?'

Because you believe that an old woman who has enjoyed life for so long she feels her soul has taken root inside her should think of death. That a woman such as you know me to be and to have been all my life should think of turning over a new leaf. That a woman who has lived such a life that the priests tell me I am heading straight for hell should now think of going to heaven. I openly admit I cannot yet bring myself to prepare for that journey, much as the priests are trying to persuade me to, nor entirely to give up those pleasures they say will hinder me. For that there is one thing I am short of and others (a pair in particular) I am over-endowed with. What I mean, of course, is that I lack remorse when what I ought to lack is greed and envy. If I hated the pile of gold I have amassed at danger to life, limb and even, some say, my eternal soul, as much as I envy my neighbour, and if I loved my neighbour as much as my money, why yes, then I might enjoy the heavenly gift of remorse.

I know from my own experience the way women are at different ages and my example confirms the saying that you can't teach an old bitch new tricks. With the years my yellow bile has increased and I can't remove my gall-bladder, as a butcher would a pig's stomach, to give it a good clean-out, so how can I be expected to resist anger? Who can rid me of my excess of phlegm and cure me of my lethargy? Who will clear my body of the melancholy humour and with it my inclination to envy? Who can persuade me

to hate ducats when I know from long experience they can rescue me from need and be the sole comfort of my old age?

O you priests and preachers, the days of my youth and innocence would have been the time to set me on the path you say I should follow now. Even though I was approaching that dangerous age when the flesh starts to itch with carnal desire, it would still have been easier for me to resist my hot-blooded urges than now to ward off the violent attacks of the three other humours combined. Address your sermons to young people, whose hearts have not yet been defiled, like Courage's, with other images, and instruct, exhort, beseech, implore them not, out of heedlessness, to let things go as far as poor Courage has done.

'But listen, Courage, if you don't mean to mend your ways, why are you going to tell the story of your life and confess all your misdeeds to the whole world?'

I am doing it to spite Simplicissimus, because it is the only way I can get my own back on him. That nasty piece of work not only got me pregnant (or so he thought!) at the spa of Griesbach and then ditched me by a mean trick, now he goes and announces our shame to the world in his fine autobiography. So I'm going to tell him what an honest pussy he was dealing with so that he'll know the truth of what he was boasting about and perhaps wish he'd kept quiet. The lesson for respectable society is that stallion and mare, whore and whoremonger are each as bad as the other. Birds of a

feather flock together, as the devil said to the charcoal-burner, and sinners and their sins are generally punished by other sins and other sinners.

Chapter 2

Libuschka, a young girl afterwards known as Courage, is caught up in the wars, calls herself Janko and for a while has to play the part of a manservant. How she behaved and what other remarkable things happened to her.

Those who know how the Slavs treat their serfs may well think I must have been got upon some peasant's daughter by a Czech noble. However, there is a world of difference between thinking and knowing. There are many things I think, yet do not know. If I said I knew who my parents were, I would be telling a lie, and not for the first time, either. But what I do know is that I had a kindly upbringing in Prachatice, was sent to school and taught more young gentlewoman's work, such as sewing, knitting and embroidery, than common girls. The money to support me was sent punctually by my father, though I could not say where from, and my mother often gave me her best wishes, although I never spoke a word with her.

When the Duke of Bavaria and General Buquoy marched into Bohemia to depose the Winter King, I was a pert young girl of thirteen and just beginning to wonder where I came from. This concerned me more than anything else because I was not allowed to ask and could not find out anything on my own. I was kept apart from other people, just as a fine painting is protected from dust, and the woman who

looked after me never let me out of her sight. I was not allowed to play with other girls of my age, and this only served to increase the fanciful imaginings which were the sole preoccupation of my precocious mind.

The Duke of Bavaria and Buquoy split forces, the former going to attack Budweis, the latter Prachatice. Budweis quickly surrendered, and was wise to do so, but Prachatice took its time and suffered the might of the imperial forces, which dealt cruelly with their obstinate opponents. Since the woman who looked after me saw the way the wind was blowing, she took me aside in good time and said, 'Libuschka, my little maid, if you want to stay a maid you'll have to have your locks cut off and put on man's clothes, otherwise I wouldn't give a button for your honour, which I have been so strictly commanded to guard.'

I thought what a strange thing to say this was, but she took a pair of scissors and cut off my golden hair on the right-hand side, leaving that on the left as it was, just the way gentlemen of rank wore it at the time.

'Well, young lady,' she said, 'if you get out of this shindy with your honour intact you'll still have hair enough to make yourself look pretty and the rest will grow again in a year.'

I was quite content with this. From earliest childhood I have always been happiest when things are at their most chaotic. After she had dressed me in breeches and jerkin, she taught me how to take longer steps and how to behave in general. Thus we

waited for the imperial troops to enter the town, she in fear and trembling, but I full of curiosity to see what new and unusual goings-on there would be. These I witnessed all too soon. However, I will not waste time describing how the men of the captured town were all butchered by their conquerors, the women raped and the town itself plundered. Such events became so commonplace in the prolonged war that is now past that all the world is only too familiar with them.

What I must tell you, if my story is to be complete, is that a German trooper, assuming I was a boy, took me with him to help in looking after his horses and foraging – stealing, that is. I called myself Janko. I could prattle away in German quite well, but like all Czechs I kept this to myself. I made a pretty boy into the bargain, delicate-skinned and with aristocratic manners. Any of you who cannot believe that should have seen me fifty years ago, then you would give a very different report of me.

When this trooper, my first master, took me to his company his captain, who was a truly handsome, young, bold cavalier, asked him what he intended to do with me.

'What other troopers use their boys for,' he answered, 'pilfering and looking after the horses, the Czechs are supposed to be best at that, or so I've heard. If a Czech's taking straw out of a house, they say, a German will never find any grain there.'

'But what,' the captain went on, 'if he starts by practising these Czech skills on you and rides off with your horses?'

27

'I'll keep a good eye on him until I've got him away from his own cowpatch,' said the trooper.

'The peasant boys who've grown up with horses make much better stable lads than the townees,' replied the captain. 'In the town they never get a chance to learn how to take care of a horse. Also, I fancy this boy comes from a respectable family and has had much too soft an upbringing to look after a trooper's horses.'

I pricked up my ears at this, though I did nothing to let them know I could follow their conversation, which was in German. What worried me most was that I might be sent back to Prachatice, which had been ravaged. I could not get enough of the thrilling sound of the fifes and drums, the trumpets and cannon. The final result – whether it was a good thing for me or bad, I could not say – was that the captain kept me to serve as his page and valet. To the trooper he gave a Czech bumpkin, since he was determined to have a thief from our nation.

I proceeded to play my role in this farce. I was so good at flattering him, at keeping his clothes clean, making sure his linen was immaculate and looking after his every comfort that he was forced to the conclusion I was the very model of a manservant. Since I was fascinated by weapons, I kept them in such good condition that both master and servants came to rely on me. Soon my captain gave me a sword as well, and dubbed me squire with a box round the ears. Everyone was surprised at the cheerful way I went about these duties and since nobody knew I had been taught German from childhood they also took

the speed with which I appeared to learn to speak it as the sign of exceptional intelligence. At the same time I made a great effort to get rid of all my woman's habits and acquire men's. I took great pains to learn to swear like a trooper and drink like a fish. I toasted everyone who seemed to be of the same rank as myself and everything I said had a plague or a pox on it, so that no one should suspect there was something I had not been endowed with at birth.

Chapter 3

Janko surrenders his maidenhead to a bold cavalry captain and in return receives the name of Courage.

As I have already said, my captain was a handsome young cavalier, a good horseman, a good fencer, a good dancer, a rapacious soldier and a keen huntsman. Setting greyhounds on hares was his favourite sport. His cheeks were as smooth as mine, and if he had dressed in women's clothes every last person would have taken him for a pretty girl. But I am wandering from the point, it is my story I am supposed to be telling. After Budweis and Prachatice had been taken the two armies besieged Pilsen, which put up brave resistance and paid for it afterwards with wholesale slaughter. From there they marched on Rakovny, where I saw my first clashes in the field. It was such stirring stuff it made my pulse race and I wished I were a man, so that I could spend my whole life making war. And this desire was only increased by the Battle of the White Mountain outside Prague, where our side won a great victory with very few losses. My captain took splendid prizes and I behaved not like a page or manservant, to say nothing of a girl, but like a soldier who has taken his oath to fight the enemy, for which he receives his soldier's wage.

After this battle Maximilian of Bavaria marched into Austria, the Elector of Saxony into Lusatia and

General Buquoy into Moravia to bring those who had rebelled against the Emperor to heel. Buquoy had been wounded at Rakovny and was forced to rest a while, during which time I was wounded too, for my captain's charms had pierced my heart. I only had eyes for the qualities I listed above and was blind to the fact that he could neither read nor write and was a coarse brute whom I swear I had never seen nor heard praying. Alfonso the Wise may well have called him a handsome animal, but that would have done nothing to douse the fires of love in my breast. However, what was left of my maidenly modesty urged me to keep them secret, which I did, though very grudgingly. Although I was so young I was hardly ready for a man, I often wished I could take the place of those I and others procured for him now and then. Another thing that stopped me taking the dangerous course of revealing my love prematurely was the fact that my beloved came from a well-known noble family, so that I imagined he would not think of marrying someone who did not know who her parents were. At the same time I didn't want to become his mistress because every day in the army I saw so many whores prostituting themselves.

Although this battle I was fighting with myself was agonising, I still remained cheerful and full of high spirits. My nature was such that neither my inner torment nor the physical labour and troubled times caused me any worry. True, all I had to do was to look after my captain, but the love I felt for him taught me to do it with such zeal, such ardour that my master would have sworn blind there was no

more faithful servant in the whole world. In all the fighting, however fierce it became, I never left his back or side, even though that was not part of my duties. Beyond that, I was always prompt to do anything as soon as I knew it would please him. If he hadn't been deceived by my clothes he could have read from the look on my face that I worshipped and adored him with a devotion that went far beyond that of a normal servant. The more time passed, the more both my body and my passion grew, so that I no longer felt able to conceal either the flame within my breast nor the bosom without.

After we had stormed Jihlava, conquered Trebic, forced Znojmo to come to terms, subjugated Brno and Olomouc and brought most of the other cities of Moravia under our command, I was allotted a fine share of the booty, which my captain gave me for my faithful service. With this I kitted myself out splendidly, bought an excellent horse, filled my purse and downed the occasional mug of wine with my fellows.

Once I was drinking with some who, out of envy, kept making disparaging remarks. There was one who was particularly belligerent, sneering and scoffing at the Czechs. This fool claimed some Czechs had eaten a rotting dog full of grubs as if it were a stinking cheese and even went so far in his mockery as to suggest I had been there myself. This led to insults, the insults to blows and the blows to grappling and wrestling in the course of which my opponent slipped his hand into my breeches, with the intention of grabbing me by the very piece of equipment I lacked. This vicious, if pointless move annoyed me

even more than if he had not come away empty-handed. It sent me almost half mad with fury so that I gathered all my strength and speed and put up such a fight, scratching, biting, hitting and kicking, that I took him to the ground and made such a mess of his face that it looked more like a demon's mask than a human being. I would even have strangled him if the others hadn't pulled me off and made peace. I came away unscathed but fearing this evil customer had discovered what sex I was. And I think he would have told the people there and then, except that he was afraid of either receiving more blows or being ridiculed for letting a mere girl beat him up like that. However, I feared he might eventually betray me, so I slipped away.

My captain was not there when I got back to our quarters, but out enjoying himself with other officers, in which company he heard of my fight before he returned. As he liked the pluck I showed, the dressing-down he gave me was only a relatively mild one. When, in the middle of his sermon, he asked why I had made such a dreadful mess of my opponent, I replied, 'Because he tried to grab my courage, which until now no man's hand has touched.' (I wanted to avoid a coarse expression such as the one people use for their cat; if I had my way I would ban the vulgar word and make them call their pet 'naughty cat'.) And since my virginity was as good as lost anyway, as it was likely my opponent would let the cat out of the bag, I uncovered my snow-white bosom and showed the captain my firm, attractive breasts.

'Before you,' I said, 'you see a maiden who disguised herself in Prachatice to save her honour from the soldiers. And now that God and fortune have put her in your hands, she begs you, as an honourable knight, to respect her honour.' At that I burst into such pitiful tears you would have sworn I meant it seriously.

The captain was astounded and yet he had to laugh at the new name I had invented for the unexpected delights my breeches concealed. He reassured me warmly and promised in fine-sounding words to protect my honour like his own life, but his actions showed that he would be the first to have designs on my virginity, and I have to admit that I found his lascivious groping more to my taste than his honest promise. But I put up stout resistance, not in order to escape him or his desires but to arouse his lust all the more. And I played my part so successfully that I managed to make sure nothing happened before he had promised by all that was holy to marry me, even though I could well imagine he no more intended to keep it than to chop off his own head.

So you see, my poor Simplex, you may have imagined in Griesbach you were the first to dip into the honeypot, but you deceive yourself, you booby, it was broached long ago, perhaps even before you were born. All that was left for you, my little latecomer, were the scrapings, and quite right too. But this is nothing compared with the other ways in which I duped and deceived you, all of which you will hear at the proper time and place.

Chapter 4

After enjoying married life for some time, though without the benefit of clergy, Courage becomes the captain's wife so that she can immediately be transformed into a widow.

So I lived with my captain, our love being kept secret, and performed the duties of both manservant and wife. I kept on pestering him to keep his promise and lead me to the altar, but he always had some excuse for putting the matter off. My best chances of tying him down came when I was giving him tangible proof of my wild, passionate love for him, at the same time bewailing my virginity like Jephthah's daughter, even though in fact I couldn't give a brass farthing for its loss. Indeed I was glad of it. It was like getting rid of an unbearably heavy burden since it meant I no longer had to continue my deception. However, my fondling and wheedling did manage to persuade him to have a magnificent dress made for me in Vienna. It was in the very latest fashion, just like the ones aristocratic ladies in Italy wore, so that all I was lacking was my marriage lines and being addressed as 'my lady'. This gift raised my hopes and kept me compliant, but I was not allowed to wear it, nor to go round as a woman, much less as his wife. And what annoyed me most of all was that he no longer called me Janko, nor even Libuschka, but Courage. Others copied him, without knowing the

origin of the name, assuming my master had given it to me because I used to face even the most dangerous enemies with resolution and matchless courage. I had no choice but to swallow something that stuck in my throat.

So be warned by me, all you girls who have kept your honour and maidenhead intact, and do not let it be taken so easily, for with it you will lose your freedom and end up in such slavery and torment as is worse than death itself. I've been through it and know what I'm talking about. I wasn't much bothered about the loss of my virginity, since I had never felt the urge to keep it under lock and key, but what did irk me was that I was being put off and had to accept it with good grace for fear my captain might let the cat out of the bag and expose me to public shame and ridicule.

And you men, too, who obtain such goods by deceit, beware you do not receive your just rewards from those you have given good reason to seek vengeance. Remember the Parisian gentleman who, having had his way with a lady, announced his intention to marry another. His victim lured him back into her bed, murdered him during the night, cut up his body and threw the pieces out into the street. I have to admit that if my captain had not kept me satisfied with frequent passionate demonstrations of his love, nor constantly given me hope he would finally make an honest woman of me, I would certainly have ended up putting a bullet through him.

In the meantime we had entered the Hungarian province of Slovakia under Buquoy's command and

taken Bratislava. We left most of our baggage there, especially our best things, because my captain anticipated a battle with Gabriel Bethlen, the Prince of Transylvania. From Bratislava we proceeded to Jur, Pezinok, Modra and other towns which were plundered then burnt to the ground. We took Trnava, Magyarovar and almost the whole of the Great Danube Island, but at Nitra we suffered a reverse in the course of which not only did my captain receive a fatal wound, but our general, Count Buquoy himself, was killed, at which we fled, not stopping until we were back in Bratislava. There I devoted myself to nursing my captain, but the surgeons said he was sure to die because his lung was damaged. On hearing that, devout friends persuaded him to make his peace with God, and the regimental chaplain was so zealous in his ministry he would not leave him in peace until he had confessed and received communion. After that both his father confessor and his own conscience urged him to marry me where he lay, in his bed, for the comfort not of his body, but of his soul. His mind was made up all the more quickly because I had convinced him I was pregnant. What a topsy-turvy place this world can be! Some men take a wife to live with them in married bliss and my captain was marrying me because he knew he was going to die.

Now people knew that I had served and mourned him not as a manservant but as a faithful mistress. The dress he had made for me looked magnificent at the wedding ceremony but I could not wear it for long. Only a few days later I was a widow and had to

change it for a black one. I felt like the lady who, when one of her friends commiserated with her at her husband's funeral, said, 'The Devil always takes first the thing you love most.' I gave him a splendid funeral, as was his due as a nobleman, for he had not only left me fine horses, clothes and weapons, but a goodly sum of money as well. I also had the priest write all this down, hoping I might be able to use it to get my hands on some of his inheritance from his parents. However, all that my extensive researches managed to establish was that he was of noble birth but poor as a church mouse. Had the Czechs not provided him with a timely war, he would have had trouble making ends meet.

I not only lost my dearest love in Bratislava, but was trapped there when it was besieged by Gabriel Bethlen. However, ten companies of cavalry and two regiments of infantry managed to relieve the town by a subterfuge, forcing Bethlen to abandon the siege. I took the opportunity of going to Vienna with my horses, servants and all my baggage, hoping to make my way back to Bohemia to see if the woman who had looked after me was still alive in Prachatice and find out from her who my parents were. I was very much taken with the the idea of returning home with so many horses and servants, plus a document stating I had come by them fairly in the wars.

Chapter 5

Tells of the double life Courage led as a captain's widow, both respectable and virtuous as well as wicked and depraved; how she let a count have his way with her, relieved an ambassador of his pistoles and willingly yielded to others for the rich reward it brought.

Things at that moment were very uncertain, so I did not feel like risking the journey to Prachatice straight away and stayed in Vienna. Since prices in the inns were extortionate, I sold my horses and got rid of my servants, taking a maid and a small apartment with a widow to keep down my expenses until an opportunity of getting home safely should present itself.

You would have to go a long way to meet another such out-and-out rogue as that widow. Her two daughters were no better than they should be and were well known among both the hangers-on at court and the officers. The result was that word of my presence quickly got round and soon these turkey-cocks were full of the beautiful captain's widow who was lodging with them. My black mourning outfit gave me a respectable and dignified look, at the same time setting off my beauty even more, and initially I lived a quiet, retired life. My maid had to spin and I took up sewing, crocheting and other gentlewoman's work, making sure people could see me at it. In secret, however, I decked myself out and I could

spend a whole hour at the mirror to see what effect laughter, tears, sighs and suchlike changes of expression had on my looks. This frivolity was sufficient proof of my wanton nature and a sure indication I would soon be following the example of my landlady's daughters. They, together with their mother, proceeded to expedite matters by befriending me and often coming to see me in my room to pass the time of day. During our conversations they kept telling me how unhealthy such a life of piety was for young things, especially ones with strong natural urges like myself. The old woman was a past-mistress of easy insinuation. She started off by teaching my maid how to dress me and do my hair after the latest fashion, then taught me how to make my white skin even whiter and my golden hair even more shining. When she had finished prettifying me, she said what a crying shame it was for such a splendid creature to go round in a black sack all the time, bewailing her lost mate. This was music to my ears and only served to fuel the flames of desire, which were already burning inside me anyway. She lent me *Amadis of Gaul* to while away the time and to learn pretty turns of phrase from; in short, she did everything she could think of to arouse my lust.

In the meantime the servants I had dismissed told all and sundry about me and the way I had become a captain's widow. And since 'Courage' was the only name they knew me by, I found I was stuck with it. I gradually started to forget my captain, now he was no longer there to stoke my fire, and seeing how much my landlady's daughters were in demand

whetted my appetite for something new to nibble myself. My landlady would have been delighted to supply me with such fare, even at the cost of going hungry herself, but she didn't dare broach the subject as long as I was still in mourning because of the coolness with which I received her hints on the subject. Nevertheless this did not stop some noble gentlemen from pestering her daily about me and swarming round her house like robber bees round a honey-pot.

Among them was a young count who had seen me recently in church and fallen madly in love with me. He spared no expense to gain entry to my apartment. He kept asking my landlady to arrange this, but in vain, since at that time she still did not feel she could just bring him in without a by-your-leave. So he tried another route. He found out all about my captain's regiment from one of my former servants and once he knew the officers' names he humbly begged to be allowed to come and see me to ask about his 'old friends', who, of course, he had never met in his life. From that he got to talking about my captain, claiming to have studied with him and been a close friend. He expressed grief at his early death, said how sorry he was to see me made a widow so young and that if there was anything within his power I had only to etc, etc. This was the kind of blandishment he used to make my acquaintance, and he succeeded for, although I knew very well that what he told me was nonsense (my captain had never been near a university), I was quite happy to put up with him because his intention was to take

the late captain's place in my life. However, I kept my distance and gave him a cool reception, replied curtly, managed to squeeze out a tear or two, thanked him for his condolences and kind offer of help with some nice turns of phrase which indicated he should for the moment content himself with having made contact and, as a gentleman, take his leave.

The next day he sent his lackey to enquire whether it would be inconvenient if he came to visit me. I replied that it would not be inconvenient, that his company would be welcome even, but given the number of inquisitive people around who put a suspicious interpretation on everything, I asked him to show consideration and not bring me into disrepute. This somewhat brusque answer did not annoy the count at all, indeed, it only served to increase his infatuation. He walked up and down outside the house with a melancholy look on his face, hoping at least to catch a glimpse of me at my window, but in vain. I was determined to get the best price for my goods and kept out of sight. While he was half expiring with love, I put off my mourning and donned my other dress, which I could now wear in public, and looked magnificent in it. I left out nothing that would add to my attraction, and drew admiring glances from many a grandee, though only when I went to church as I didn't go out otherwise. Every day I received greetings and *billets doux* from a variety of gentlemen, who were all afflicted with the same malady as the count. I, however, remained as unmoved as a rock until Vienna rang with praise not

only of my peerless beauty, but of my chastity and other rare virtues.

Having brought things to the point where people considered me some kind of saint, I decided the time had come to take advantage of this good opinion they had of me and give free rein to my bodily appetites, which I had so far kept in check. The count was the first I granted my favours because he had spared neither trouble nor expense to gain them. He was truly worthy of a woman's love and head over heels in love with me and I considered him the best of the whole lot to satisfy my desires; yet he would not have got so far had he not given me a bolt of dove-grey satin and all the trimmings for a new dress as soon as I came out of mourning and, most important of all, a hundred ducats to help me get over the loss of my husband. His successor was the ambassador of one of the great potentates who, for our first night together, gave me sixty pistoles. After him came others, all of whom were lavish with their money; those who were poor, or at least not rich and powerful, had to stay outside or make do with my landlady's daughters.

I managed so well that my mill-wheel was never still and so effective was my grinding that within a month I had bagged over a thousand ducats in hard cash, not counting the gifts of jewels, rings, chains, bracelets, velvet, silks and linen (no one had any hope who turned up with nothing but stockings and gloves) as well as food, wine and other things. Remembering the saying:

With every passing day
Our beauty fades away.

I determined to continue to make the most of my youth. Even today I would regret it if I had done less. Eventually, however, I went about it so openly people began to talk and I could see the writing was on the wall. By now I was letting even ordinary men into my bed.

My landlady devoted herself to helping me, at the same time turning an honest penny for herself. She taught me all kinds of cunning tricks such as were used not only by women of easy virtue but by the kind who go round with brigands as well. She even showed me how to make myself bullet-proof and a spell to render any man's gun useless, if I wanted. I think if I had stayed much longer with her I would have become a regular witch myself. However, I received a friendly warning that the authorities were planning to raid our den and clear it out, so I bought a carriage and a pair of horses, hired a servant and quietly slipped away, having found a good opportunity of getting safely to Prague.

Chapter 6

A strange fate brings Courage a second marriage to a captain with whom she lives an exceedingly happy and contented life.

There would have been plenty of scope for me to ply my trade in Prague, but the desire to see my foster mother and find out about my parents drove me on towards Prachatice. I felt sure there was no risk in this, as the region was at peace, but damn me if one evening, when we were already in sight of the town, eleven troopers of Count Mansfeld's regiment didn't ride up. They were all wearing red sashes or badges, so I assumed, as anyone would, that they were imperial troops and therefore friendly. They seized me and set off with me and my carriage towards the Bohemian Forest as if the very devil were on their tails. I screamed as if I were being tortured, but they soon put a stop to that. Around midnight they came to a lonely farmhouse in the woods where they set about feeding the horses and themselves, and using me the way soldiers generally use their women captives. This did not bother me in the slightest, but they got more than a taste of their own medicine, for, while they were satisfying their animal lusts, they were surprised by a captain with thirty dragoons, who had been escorting a convoy to Pilsen, and, since they were wearing false colours, all put to the sword.

The Mansfeld troopers had not yet shared out my

possessions and since I had an imperial pass and had been in captivity for less than twenty-four hours, I pointed out to the captain that he could not declare me and my possessions legitimate booty and keep them. He was forced to admit the truth of what I said. However, he went on, I was under an obligation to him for having rescued me and no one would blame him for not wanting to relinquish such a hoard as he had captured from the enemy. If I was a captain's widow, as my papers claimed, he, for his part, was a widowed captain, and if I was willing, the booty would soon be shared. If not, he would still take me with him and be prepared to argue with anyone whether it was legitimate booty or not. From this I could tell he had already taken a fancy to me and to encourage me to make up my mind, he graciously offered me the choice between having my goods divided up among his men or marrying him so that I and my goods would belong to him alone. In the latter case he would tell his men that I and my possessions were not legitimate booty but had simply become his property through marriage.

I replied that if I really had a choice I would ask for neither, but to be allowed to continue on my way to my home. At that I began to cry as if I truly meant it, following the old rhyme:

> See a woman sob and cry
> Enough to melt the heart of any man.
> It's all pretence, a cunning lie –
> When she wants to shed a tear, she can.

Knowing how easily men are moved by a woman's sadness and tears, my aim was to get him to comfort me and thus fall all the more deeply in love with me. My play-acting was successful and when he tried to cheer me up with solemn professions of love I agreed to marry him, though only on the express condition that he would not touch me before the wedding. This he both promised and kept until we were inside the fortified camp in Weidhausen, which Count Mansfeld, following their agreement, had only recently handed over to the Duke of Bavaria

So urgent was my betrothed's love that we could not put the wedding off any longer and we were wedded and bedded before he had any chance to learn how Courage had earned her not inconsiderable wealth. I had hardly been with the army for a month when some senior officers arrived who had not only known me in Vienna, but had been among my best customers. However, they were discreet enough to say nothing in public that would besmirch either their own or my honour. There was the odd whisper, but nothing that troubled me, apart from the fact that once more I had to put up with being called 'Courage'.

I had a good and indulgent husband who was as delighted with my golden guineas as he was with my beauty. He was more sparing in his use of the latter than I would have liked, but I accepted it, since he allowed me all the more freedom in my behaviour and conversation with others. If anyone teased him that he would end up with a fine pair of horns he would reply jokingly that that was the least of his

worries. If someone slept with his wife, he said, he would not leave it at that but would take the time to put the finishing strokes to the other man's spadework.

He kept an excellent horse for me, with a fine saddle and bridle. Unlike the other officers' wives, I did not have a woman's but a man's saddle, and although I rode side-saddle, I still kept pistols and a Turkish sabre by me and had a stirrup on the other side; I also wore breeches with a thin taffeta skirt over them so that in a trice I could be astride my horse and ready to fight like any trooper. If there was an encounter with the enemy I found it impossible to stand aside and not join in. I often said that a lady who was not prepared to defend herself against a man on horseback should not deck herself out in plumes like a man. After I had had the good fortune, in the course of several skirmishes, to capture a few soldiers who thought themselves no cowards, I became so bold as to carry a carbine at my side when such a clash was likely, and would even take on two at a time in single combat. My resolution in these encounters was only increased by the fact that the spell my aforementioned landlady had taught me meant both I and my horse were proof against any bullet.

That was the life I led. I took more booty than some of the soldiers themselves. There were those among them who were annoyed by that, but it didn't bother me, indeed, it gave my exploits added spice. Although my husband was a much less vigorous lover than I would have liked, he showed such trust in me

that I could not bring myself to be unfaithful, despite the fact that much higher-ranking officers offered their services, for he let me come and go as I pleased, but this did not stop me being merry in company and pert in conversation. Facing the enemy I was as bold as a man, while in camp I was as good and thrifty a housewife as any woman, looked after his horses better than a groom and had such a knack of finding the best quarters that my captain could not have wished for a better wife. And if, now and then, he felt the need to upbraid me, he did not object when I gave as good as I got and insisted on going my own way, because this increased our wealth so much that we had to send a good portion of it to a reputable city for safe keeping.

So I lived an exceedingly happy and contented life, my only wish being that my husband might have a little more fire in his loins. But fortune, or my destiny, did not leave me long in that state, for my captain was shot dead at Wiesloch and soon I was a widow again.

Chapter 7

Courage proceeds to marry for the third time, exchanging the status of a captain's wife with that of a lieutenant's. However things don't turn out so well this time and she and her lieutenant fight with cudgels about who is to wear the trousers. She wins, thanks to her determination and courage, and her husband walks out on her and disappears.

My husband's body was scarcely cold in its grave when once more I had a whole dozen suitors to choose from, for I was not only young and beautiful, I had fine horses and a fair sum of money. Even though I let it be known that I intended to go into mourning for my captain for six months, I could not keep off the importunates who came swarming round me like bumblebees round an open honeypot. The colonel promised me board and lodging with the regiment until I had sorted my affairs out. I for my part got two of my servants to perform the services their late master could no longer provide, and whenever I thought there was an opportunity of grabbing something from the enemy I was as ready to risk my neck as any soldier. In that pleasant, not to say lively encounter at Wimpfen I captured a lieutenant and, not far from Heilbronn during the following pursuit, a cornet with his standard. My two servants made a good haul of money from the plundering of the baggage train

which, according to our agreement, they had to share with me.

After that battle I had even more admirers than before, and seeing that with my previous husband I had had more good days than good nights, also taking into account the fact that since his death I had been on short commons, I decided to choose a man who would make up for everything I had been missing, a man who, to my eyes, outshone all his rivals in looks, youth, intelligence and bravery. He was Italian by birth, had black hair and white skin, and I thought him more handsome than any artist could paint. He behaved towards me with all the fawning humility of a spaniel, and when I agreed to marry him he went into raptures, as if God had reserved the delights of heavenly bliss for him alone. The wedding took place in the Imperial Palace at Wimpfen and we were honoured with the presence of the colonel himself and most of the senior officers, all of whom wished us – though in vain – a long and happy marriage.

As the sun was rising after our first night together we lay in bed chatting and whispering endearments. I was about to get up when my lieutenant called his boy into the bedroom and ordered him to bring two stout cudgels. Assuming the poor lad was the one they would be tried out on, I pleaded for him until he returned with the cudgels and put them, as ordered, on the table where our clothes were. After he had left, my husband of one night said to me, 'Now my love, you know that everyone believed you wore the trousers when your former husband was alive, and decent people spoke scornfully of him because of it. I have

good reason to believe you intend to continue this habit, and I could not abide it, or at least would find it difficult to endure. As you can see, the trousers are there on the table, together with those two cudgels, and if you want to keep on wearing them, then I'm afraid we will have to come to blows to decide who gets them. I think even you would agree, my darling, that it is better one or other of us gets them right from the start, instead of having to fight over them every day of our marriage.'

'Dearest,' I replied, giving him a smacking kiss, 'I would have thought the cut-and-thrust between us had already taken place. It never occurred to me to try and wear the trousers in our marriage. I know that woman was taken from man's side, not from his head, and I did hope my beloved would bear that fact in mind and treat me as his spouse, not as his door-mat, as if woman had been taken from the soles of man's feet. As you can see, I don't sit on your head, but take my proper place at your side, and I humbly beg you to give up the notion of this ridiculous duel.'

'Ha!' he said, 'that's a typical woman's ploy for taking command before a man realises what's happening. We have to fight first so that I shall know which of us owes obedience to the other in future.'

With that he wrenched himself from my embrace as if he had been struck with madness. I, however, jumped out of bed, slipped into my shift and drawers, grabbed the shorter but stouter of the two cudgels and said, 'Since you order me to fight and insist the winner will have authority over the other (something I never desired to claim), I would be a

fool to let slip the opportunity of getting something I wouldn't otherwise have thought of aspiring to.'

He wasted no time either. Seeing me ready to meet him, he pulled his trousers on, took up the other cudgel and tried to grasp me by the head in order to hold me while he gave my back a good thrashing. But I was much to quick for him. Before he knew what was happening he had a whack on the head which sent him tumbling to the ground like a felled ox. I gathered up the two cudgels, intending to throw them away, but when I opened the door I found several officers outside who had heard our altercation, some even having peeped through a gap. I left them to their laughter, slammed the door in their faces, threw on my dress and revived my numskull of a husband by pouring the contents of the washbasin over his face. Once I had him sitting at the table and had made myself decent I let in the officers who were waiting outside.

You can imagine the looks we gave each other. I realised that my dear husband had arranged for the officers to meet outside our room at this time to act as witnesses to his stupid scheme. When, before the marriage, they had teased the dimwitted stud that I would soon be wearing the trousers, he had replied that he had a cunning plan he was going to put into effect the morning after our wedding. This would make me so biddable, he claimed, he would only have to look at me to have me trembling in my shoes. But the poor fellow picked on the wrong woman in Courage. All he achieved was to make himself the laughing stock of the whole regiment and I would not have

gone on living with him if it hadn't been ordained by the holy sacrament of marriage. You can well imagine the cat-and-dog life we led together. When he found it impossible to get his own back on me and the general mockery became unbearable, he pocketed all my ready cash and went over to the enemy with my three best horses and one of the servants.

Chapter 8

Courage puts up a lively show in a skirmish, chops off one soldier's head, captures a major and learns that her lieutenant has also been captured and executed as a deserter.

So I became a demi-widow, a state which is much worse than having no husband at all. Some suspected we had planned our flight together and I would follow him. However these suspicions were allayed when I asked the colonel for advice and what his orders were and he said I could stay with the regiment and as long as I behaved myself he would see that I was provided for in the same way as other widows.

My ready cash having gone, and also the splendid mounts on which I had taken so much booty, I had to husband my resources, so to speak, but I took care no one should see how poor I had become so that they wouldn't look down on me. I still had the services of my two servants as well as a boy, plus a few old packhorses. I converted these nags and whatever I could of my husbands' baggage into ready cash and bought myself an excellent mount from the proceeds. As a woman I wasn't allowed to go out on raids, but no one could match me at foraging. I often wished there would be a battle, as at Wimpfen, but I just had to be patient and bide my time. They weren't going to hold a battle just for me, even if I asked! In order to come by some cash, which we

seldom found when foraging, I took to engaging in hand-to-hand combat with those of our officers who were free with their money (both to earn some for myself and to pay my runaway husband back for deserting me). Thus I managed to make ends meet and even hired a strong lad as a servant who had to help me steal while the other two stood watch.

I carried on in this way until we defeated the Duke of Brunswick at Höchst and drove him back over the River Main, in which many of his soldiers drowned. I joined our troops in that encounter and fought to such effect in our colonel's presence that he said he would not have believed the courage I showed even from a man. In the mêlée I captured a major right in front of his troops as he was about to renew the attack. One of his men tried to rescue him and fired his pistol at my head, sending my hat and plumes flying. I replied with such a clean blow of my sword that he rode along headless beside me for several steps, a sight which was both bizarre and revolting. After the major's squadron had been scattered and put to flight, and he had given me a well-filled purse of gold coins together with a gold chain and valuable ring in return for his life, I made him swap horses with my groom and handed him over to our side.

Then I went to the broken bridge, which was surrounded by men drowning pitifully in the water or being mercilessly slaughtered on the land. Since as far as possible all the soldiers still had to keep with their units, I grabbed a coach with six fine bays. There were no people or money in it, but I did find two chests full of expensive clothes and linen. With

my groom's help I took it back to where I had left the major, who was mortified to have been captured by a young woman like me. But when he saw me reloading my carbine and the pistols I had in my trousers pockets as well as in my holsters and heard what I had done at the battle of Wimpfen he felt slightly less humiliated and said the devil himself would have trouble with a witch like that.

I went off with my groom (whom I had made as bullet-proof as myself and my horse) to get my hands on more booty, but we came across the lieutenant-colonel of our regiment lying under his horse. He knew me and called out for help, so I packed him on my groom's horse, took him back to our lines and stowed him in the coach I had just taken, where he had to keep the good major company.

It is unbelievable how everyone, friends and enemies alike, praised me after this battle, both saying I was the very devil. At that time my greatest wish was to be a man and not a woman, but what was the point? It was an impossible dream. I did toy with the idea of pretending to be a hermaphrodite, which might allow me to wear trousers in public and pass myself off as a young man. Unfortunately my inordinate desires had made it very clear to so many men precisely what sex I was that I felt the task was beyond me, however attractive I might find the idea. So many witnesses would appear to claim I was not what I appeared to be that I would have to be examined by both doctors and midwives. I just had to make the best of it and if I got told off too often I

reminded them of the Amazons, who had defended themselves against their enemies as bravely as men.

To keep in the colonel's good books and assure myself of his protection against those who were envious of my success, I presented him with my prisoner and the coach and horses. In return he gave me two hundred imperial thalers which, together with the money I had accumulated by way of booty and other earnings, I once more sent to a large town for safe keeping.

Having taken Mannheim and besieged Frankenthal, we were masters of the Palatinate. Meanwhile General Corduba and the Count of Anhalt had defeated Mansfeld and the Duke of Brunswick again, this time at Fleurus. In the course of that battle my runaway husband, the lieutenant, was captured, recognised as a deserter by our regiment and strung up from the nearest tree by his precious neck. This released me from my husband and made me a widow once more, but it also brought me a host of enemies who kept saying, 'That witch killed the poor devil,' so that I found myself wishing he had lived a bit longer and found a more honourable death somewhere else.

Chapter 9

Courage quits the wars since her luck has deserted her and almost everyone treats her with scorn.

And so it happened that the longer things went on the more bother I had to put up with. My servants left me because people kept saying to them, 'How can a man like you work for a cow like that, for God's sake?' I hoped to get another husband, but they said to each other, 'You take her, I don't fancy her.' All decent people shook their heads at me, as did most of the officers. As for men without position or wealth, there was no point in them approaching me, I would never even have looked at one of them. The consequences of our stupid duel were not fatal for me, as they were for my husband, but I suffered from them for longer than he had from the noose. I would have liked to become a different person, but both habit and the company I kept made it impossible for me to reform. It is a sad fact that in war most people get worse rather than better, and I was no exception. I dolled myself up again and baited the hook for this or that man, hoping I might make a catch, but it was no use, my reputation went before me. Courage was well known throughout the army and whenever I rode past a regiment a thousand voices bore witness to my notoriety so that I was compelled to become a night-owl, not showing my face by day. When we were on the march the respectable women avoided

me, the riff-raff with the baggage train tormented me and those unmarried officers who would have protected me for the sake of their nocturnal pleasure had to stay with their men, who poured scorn on me with their ribald comments. I could see that in the long run there was no future for me there. There were some officers who were still friendly with me, but only for their own advantage, not for mine. They were after either my body, my money or my fine horses, but they were all parasites who caused me more trouble than they were worth and not one of them was interested in marrying me. Either they were ashamed of me, or they imagined I brought bad luck to all my husbands or they were otherwise afraid of me, why, I couldn't say.

I therefore made up my mind to quit not only the regiment, but the army, indeed the whole war. This was all the easier because the senior officers had long wanted rid of me. Indeed, I would be deceiving myself if I thought there were many respectable folk who shed a tear at my departure, apart from a few unmarried young bucks among the middle-ranking officers who had slipped in between my sheets now and then. The colonel was unhappy that it was a well-known fact that his splendid carriage was a gift from Courage, who had captured it from the enemy; the lieutenant-colonel felt so embarrassed that I had rescued him from danger when he was wounded and seen him back to the safety of our own lines, that he not only thanked me for my trouble with a 'Damn' bitch!' but also flushed with annoyance whenever he came across me and, as you can well imagine, wished

me to the devil. The young ladies and the officers' wives hated me because I was more beautiful by far than anyone else in the regiment, and especially because some of their husbands even preferred me; and soldiers of all ranks couldn't stand me because I had as much guts as any of them to carry out actions demanding the greatest courage and boldness which had many of them soiling their undergarments in terror.

I could easily see that I had a lot more enemies than friends and could just as easily imagine every single one of the former would not hesitate to harm me in their own particular way should the opportunity present itself. 'O Courage,' I said to myself, 'how are you going to escape when you have so many enemies, each one perhaps planning their own attack on you? Your fine horses, beautiful clothes, splendid weapons and the belief that you have lots of ready cash alone would be enough for some enemies to incite a few of the men to get rid of you quietly. What if they should kill you during a skirmish? Would anyone care twopence? Who would avenge your death? What? Can you even trust your own servants?' I tormented myself with these and similar worries and tried to make up my mind what to do. As there was no one I could turn to for advice, I had to decide on what course of action to take myself.

I applied to the colonel for a pass to the nearest imperial city, which happened to be close at hand and well situated for me to get away from the armies. I was not only granted one without fuss, he also, in place of discharge papers, provided me with a

document stating I was the lawful wife of a captain in the regiment (for I wanted nothing to do with my last husband), who had been killed in action. Since then I had stayed with the regiment for a while, during which time my conduct had been devout and seemly, as befitted an honest, respectable and virtuous young lady of unblemished reputation, for which reason he was happy to recommend me to anyone it might concern. To these blatant lies he appended his own signature and official seal. There is no reason to be surprised at this. The worse people behave and the more others want to get rid of them, the more magnificent the testimonial will be, especially if it is in lieu of wages. As a token of gratitude I left a servant, kitted out as well as any officer, with a horse to add to his company. For my part I took with me one servant, one stable lad, one maid, six fine horses (of which one was worth a hundred ducats) together with a carriage bulging at the seams. In all conscience (some insist mine is a very elastic conscience) I could not say exactly how I came by all these things.

Having got myself and my possessions to the safety of the above-mentioned city, I sold off my horses and disposed of everything else I no longer needed which could be turned into cash. I also dismissed all my servants in order to reduce my outgoings. But the same happened to me here as had happened in Vienna. Once more I could not rid myself of the name 'Courage' even though it was the one thing I would have been happy to let go at a knock-down price. My old (or rather, young) customers from the army rode into the city to see me

and enquired after me by that name, which the street
urchins picked up more quickly than the Lord's
Prayer, for which reason I gave my suitors the two
fingers. When, however, they told the inhabitants
what kind of woman I was, I was forced to respond
with a statement, signed and sealed, saying that the
only reason the officers spread such tales about me
was that I refused to give way to their entreaties. By
this I managed to wriggle out of the awkward situ-
ation and even managed to use the colonel's testi-
monial to get the city, for a small consideration, to
take me under its protection until I could arrange my
affairs. Once again, and against my will, I lived a
respectable, devout, quiet and retiring life, doing my
utmost to care for my looks, whose beauty increased
daily, hoping in time to win another lusty husband.

Chapter 10

Courage learns who her parents were and acquires another husband.

But I would have had to wait a long time before anything decent took the bait. The men of good family stuck with their own kind and any who were rich could easily find some rich and beautiful maiden of – what at that time still mattered to a certain extent – untarnished reputation. There were some on the other hand who, having gone bankrupt or expecting to do so shortly, wanted my money but I, for precisely that reason, did not want them, and tradesmen were just too ordinary for me.

So I remained on the shelf for a whole year, which was hard to bear and completely against my nature, especially since the good life I enjoyed only made the itch worse. All I needed to do was to loan the money I had here and there in the big cities to merchants and financiers and I made such a tidy profit that I could live well without having to spend any of my capital. The pinch I felt was in quite a different place from my purse and since my weak body could not – or would not – put up with this good life any longer, I transferred my money to Prague and went, in company with a number of merchants, to take refuge with my old foster-mother in Prachatice and see if I might have better luck there.

I found her very poor, worse off than when I left

her. It was not just the wars that had brought her down in the world; even before they broke out she had eaten with me rather than I with her. She was delighted to see me, especially when she realised I wasn't coming empty-handed. She gave me a very tearful welcome, however, calling me an unfortunate young lady who would find it difficult now to live a life commensurate with my rank and lineage, adding that she was no longer in a position to help and advise me, or act as my guardian, since all my friends and relatives were either dead or in exile. Moreover, she said, I would do well to keep clear of the imperial troops in case they should discover who my parents were. At that she burst into tears again and wouldn't stop crying so that I couldn't make head or tail of what she was saying. Food and drink soon cheered her up, as the poor woman's cupboard was almost bare, and once she was her old self – her old tipsy self – again she was happy to tell me who my parents were.

My father, she said, was a count who until a few years ago had been the most powerful in the whole kingdom. Now, however, he had been driven out of the country because of his rebellion against the emperor and was reported to be with the Turkish sultan at the Porte, where it was rumoured that he had exchanged his Christian religion for that of the Turks. My mother, she went on, was from a good family, but was as poor as she was beautiful. She had been a maid of honour with the aforesaid count's wife, and while she waited on the countess the count had served her to such good effect that he had had to take her

away to a castle where she had given birth to me. And since she, my foster mother, had just weaned a young son she had from the nobleman who owned the castle, she was made my wet-nurse and later appointed to bring me up as a noblewoman in Prachatice. Both my father and my mother had provided plentiful means for my keep. 'Your father did promise you to a bold nobleman,' she concluded, 'but he was captured when Pilsen fell and, along with many others, executed as a traitor by the imperial forces.'

Thus I learnt what I had long wanted to know yet now wished I had never learnt since I could expect nothing but trouble from my exalted birth. The only course I could think of was for my old nurse to become my mother and I her daughter, which we duly agreed. She was much craftier than me, so I followed her advice and we left Prachatice for Prague, not just to get away from the people who knew us but to see if our luck might change there. We were well suited to each other. By that I don't mean I was a born whore and she a bawd, but that she needed someone to provide for her and I someone devoted to me, as she was, to whom I could entrust both my reputation and my possessions. As well as clothes and jewellery, I had three thousand imperial thalers in ready cash and therefore no need to descend to shameful means to make ends meet. I dressed my mother like a respectable old lady, showed her all due respect and obeyed her every command in front of other people. We gave out the story that we had been driven away from our home on the German border by the wars, and we supported ourselves by

needlework, including embroidery in gold, silver and silk. For the rest we lived quietly and kept ourselves to ourselves, also keeping a close eye on my money as it's easy to fritter it away and you can't get more just because you happen to want it.

It would have been a good life we led, a godly life almost, if only we had had the strength of mind to persevere in it. I soon had admirers. Some approached me as they would a woman in a brothel, while other boobies, who were too bashful to offer to pay for my favours, rambled on about marriage. Both, however, wanted the same thing, namely to persuade me that their lust was an expression of the irresistible love they felt for me. If I had had the slightest inclination towards chastity, I would not have believed a single one of them. As it was, it was a case of 'birds of a feather flock together'. People also say, 'A spindle in your sack, straw in your shoes and a whore in your house you cannot conceal, try as you choose,' and in no time at all I was known and my beauty on everyone's tongue. At least it brought in a lot of work for our needles.

Among other things we were making was a sash for a captain who claimed he was dying of love, and when I made a great song and dance about my chastity, he behaved as if he was in despair. You see, I assessed my customers, especially their ability to pay, according to the yardstick of the landlord of the Golden Lion in N. He used to say, 'If a customer is very polite and keeps making compliments it's a certain sign that either his pockets are empty or he doesn't propose to spend much. If, on the other hand,

someone comes swaggering in, rapping the table for service and generally behaving in an imperious manner, then I think to myself, "Oho, there's a man with a bulging purse, I'll make sure he pays through the nose." I deal with the polite customer politely, so he'll recommend me and my inn to others, and give the loudmouth everything he demands so I can make plenty of demands on his purse.' I treated my captain as the landlord his polite customer so that he assumed I was, if not almost an angel, then at least a paragon of chastity, not to say virtue incarnate. Eventually I got him to the point where he started to talk about marriage and kept on about it until I agreed to take him.

The marriage contract stipulated that I should hand over to him a thousand imperial thalers in ready cash; for his part he was to deposit the same amount in his home in Germany, so that I could recover my money if he should die before me without heirs. My other two thousand thalers were to be invested in some safe place and my captain was to enjoy the interest as long as the marriage lasted, but the capital was to remain untouched, until such time as we had heirs. I also had the right, should I die without heirs, to bequeath the whole of my estate, including the thousand thalers, to whomsoever I wished. Once we had reached this agreement the wedding was celebrated. Then, just when we were thinking we could spend the war living a peaceful life in the garrison in Prague, what should happen but orders came to march to Holstein for the war against Denmark.

Chapter 11

Courage, having started to lead a virtuous life, unexpectedly becomes a widow again.

I equipped myself excellently for the campaign, since I knew even better than my captain what was needed. And fearing that I would come to places where Courage was already known, I told my husband my whole life, apart from the occasional whoring, up to the present, including what had happened between me and the cavalry captain. As to the name of 'Courage', I persuaded him I had earned it through my bravery, that being, in fact, the general belief. In this way I forestalled anyone who might try to blacken my name by telling him all this and more than I would have liked. Just as he found it difficult to believe I had fought the enemy in open combat until it was confirmed by others in the army, he subsequently refused to believe those who treated him to some of the more disreputable episodes from my past because I denied them. He was very thoughtful and sensible in everything he did, a fine figure of a man and a brave one too. I often wondered why he had taken me when he really deserved a decent, honest wife.

I took my foster-mother with me as housekeeper and cook, since she didn't want to be left behind. I filled our baggage wagon with everything one could think of that might be needed in the field and got the

servants so well organized that my husband did not need to see to it himself, nor to engage a steward for them. Myself I equipped as before with horse, arms, saddle and bridle. Thus kitted out we came to the Gleichen castles by Göttingen where we joined Tilly's army. I was soon recognised and my presence broadcast by most of the regimental wits: 'Hey, look at this, lads! A good omen that we're going to win some battles.' – 'Why?' – 'Courage is here again.' And these buffoons were not that far from the truth, for the troops I came with were not to be despised, amounting to three cavalry and two infantry regiments, reinforcements which would have given the army courage enough, even if I had not been among them.

As far as I remember, it was the second day after we joined with Tilly that we came up against the King of Denmark at Lutter. I was determined not to stay with the baggage train, and once the heat of the initial enemy onslaught had died down and our troops went back on the offensive, I joined in where the fighting was thickest. I didn't want to capture some common soldier, but to show my husband right from the start that I had not gained my nickname without reason, nor that he need be ashamed of it. So I used my sabre to good effect, making room for my splendid stallion – there was not a horse to equal it in all Prague – until I got hold of a cavalry captain from a noble Danish family and brought him back to my baggage wagon. Both my horse and I had to take some hefty blows, but neither of us shed a drop of blood in the field, the only damage being some bumps

and bruises. Since things had gone so well, I reloaded my carbine and brought back a quartermaster and a trooper, neither of whom realised I was a woman until I had taken them back to our lines to join the abovementioned captain. I did not need to search them, as each handed over his money and valuables of his own accord.

The captain in particular I made sure was treated extremely politely and not even touched, never mind stripped. However, I did deliberately move to one side for a while to let my servants swap clothes with the two others because they were kitted out with excellent jerkins. I would have ventured out a third time, continuing to strike while the iron was hot and the battle still in progress, but I did not want to ask too much of my horse. At the same time my husband also received a small part of the booty from the sol-diers who had withdrawn into Lutter Castle and then thrown themselves on our mercy, so that all in all we had taken a thousand crowns off the enemy. Immediately after the battle we deposited the money and transferred it without delay to be added to my two thousand thalers in Prague, since we did not need it in the field. Indeed, we daily expected to take more booty.

The longer we were together, the more my hus-band and I came to love one another, and we each considered ourselves fortunate to be married to the other. If we had not found it embarrassing, I think I would have stayed by his side day and night, whether in the trenches, on watch or in all the skirmishes. We bequeathed all our goods to each other, so that the

survivor would inherit everything, whether we had heirs or not, though with the obligation to care for my foster-mother as long as she lived, for she had been both hard-working and loyal to us. We made duplicate copies of our wills and deposited one with the Senate in Prague and the other in my husband's home in South Germany, that at the time was thriving, not having suffered at all in the wars.

After the battle of Lutter we took Steinbruck, Verden, Langenwedel, Rotenburg, Ottersberg and Hoya. My husband was left in command of some troops in the castle at Hoya, but with no baggage, as that stayed with the regiment, which was going into winter quarters. I was supposed to remain with the baggage and enjoy the delights of winter quarters, but no danger could keep me apart from my husband. I refused to let him stay in the castle without me for fear he would be eaten up by lice, as there were no women to keep the men clean.

Once Tilly had thus distributed his men at the onset of winter, the King of Denmark arrived with an army to try and win back in the winter what he had lost in the summer. Initially he attempted to take Verden, but that proving too tough a nut to crack, he left the city to its own devices and vented his anger on Hoya Castle. In the course of seven days he riddled its walls with over a thousand cannon-balls, one of which struck my husband, making me a widow, and a sorrowful one at that.

Chapter 12

Courage suffers the consequences of her own courage.

As bad luck would have it, while I was leaving, tearful and downcast, with our men, who had surrendered to the enemy for fear the castle might collapse on top of them, I was seen by the major from the Duke of Brunswick's regiment whom I had taken prisoner at Höchst on the River Main. At once he confirmed my identity with our men and when he heard that I had just become a widow he grabbed his chance and separated me from the company.

'You damn' witch,' he said, 'now I'm going to pay you back for the shame you brought on me a few years back at Höchst. I'll teach you such a lesson you won't take the liberty of capturing a gentleman – nor even bear arms – ever again.' He looked so fearsome that the very sight of him made me tremble, though if I had been mounted on my black stallion, face to face with him in the field, I'm sure I would soon have made him change his tune.

He deposited me in the middle of a troop of cavalry and left me in the charge of the ensign, who asked me all about my previous dealings with the lieutenant-colonel (as the major had now become). In return he told me how letting himself be taken prisoner by a woman had almost cost him his head, or at least his post as major since, with their officer gone, his troops became disordered and fell into complete

disarray. His saving excuse was that he had been
blinded by magic, but he still felt so ashamed that
eventually he resigned and took service in the Danish
army.

We spent the following night in a billet which had
little to recommend it. There, in revenge for what he
called his day of shame, the lieutenant-colonel forced
me to yield to his animal lusts though – shame on the
fool! – there was no question of enjoyment or pleas-
ure in it, for although I didn't particularly resist he
insisted on giving me smacks and thwacks instead of
kisses. The next day they left in a great hurry, like
hares with greyhounds at their heels, so that I
assumed Tilly was pursuing them, though in fact
they were only fleeing out of their own fear of being
pursued. The second night they found quarters
where the farmer had something to put on the table,
so my bold hero invited a few officers of like kidney
to join him in a particularly tasty dessert, namely
me; at least it meant my normally insatiable desires
were satisfied for once. The third night, after they
had once more spent the day fleeing as if the devil
himself were after them, I fared no better, indeed,
much worse. After I had once more been mounted (I
would almost be ashamed to say it if I weren't doing
it for your sake, Simplicissimus) by all the stallions
until they were exhausted, and had barely survived
the experience, I was forced to let the gentlemen
watch their servants ride me.

So far I had put up with everything patiently, even
thinking I deserved it for my past behaviour, but this
was going too far. In disgust I started wailing and

cursing and calling on God to come to my aid and avenge me. But these monstrous beasts showed no mercy. Devoid of all shame and Christian decency, they stripped me naked as I was born, threw some handfuls of peas on the floor and poked and prodded me with sticks to make me pick them up. They even seasoned me with salt and pepper, making me prance and cavort like a donkey that's had a bundle of thorns or nettles tied under its tail. Had it not been wintertime, I do believe they would have scourged me with stinging nettles.

Then they gathered round to discuss whether to abandon me to the tender mercies of the stable lads or have me tried as a witch by the executioner. The latter course, they decided, might rebound on them, since they had all tasted of my body. If they had intended to institute such proceedings against me, the more intelligent among them said (if one can talk about even a spark of human intelligence in those animals), then the lieutenant-colonel should not have touched me at all but handed me over to the authorities. So their conclusion was that in the afternoon (for they were going to spend that day in their safe hide-out) I would be handed over to the stable lads.

When they had finally seen enough of the wretched pea-picking show, they let me put my clothes back on and I had just finished when a gentleman came to speak with the lieutenant-colonel. It was the very same cavalry captain I had taken prisoner at Lutter who had heard that I had been captured. When he asked the lieutenant-colonel about me, saying he wished to see me because I had

captured him at Lutter, the lieutenant-colonel immediately led him into the room, saying, 'There's the bitch, I'm going to hand her over to the lads right away.' He assumed the captain would want to take similarly cruel revenge on me, but that honest gentleman had something quite different in mind. Hardly had he seen me sitting there so miserable than he started to sigh and shake his head. I immediately noticed he felt sorry for me and fell down on my knees, begging him, as he was a noble gentleman, to have pity of a poor lady and save me from further shame. He raised me by the hand and said to the lieutenant-colonel and his comrades, 'Well, my dear sirs, and what have you done to this lady?'

'What? Lady?' broke in the lieutenant-colonel, who was already half sozzled, 'She's a witch!'

'Forgive me, sir,' replied the captain, 'but as far as I know she's the legitimate daughter of old Count T., a gallant hero who has risked all his resources of people and property, even life and limb, in the common cause, so that I do not think the king would be pleased to hear that a child of his had been treated in this manner, even if she has taken a few of our officers prisoner for the imperial side. Indeed, I do believe that at this very moment her father is doing more to harm the emperor in Hungary than many a man in command of a brigade of dragoons.'

'Huh!' answered the lout of a lieutenant-colonel, 'And how should I have known? Why did she keep her trap shut?'

The other officers, who knew the captain well and were aware that he not only came from a noble

Danish family but also stood high in the king's favour, humbly begged him to overlook the matter and, since what was done could not be undone, to sort it out so that they should not suffer for it. They would, they added, be much obliged to him and would put their selves and their goods at his disposal whenever occasion arose. They all went down on their knees to beg my forgiveness, but the only forgiveness they got from me was my tears. Thus I was released – cruelly abused, it is true – from the power of those brutes, and came into the hands of the captain of horse, who behaved towards me with much greater courtesy. Without even touching me, he sent me, with a servant and a trooper from his company, to a castle in Denmark that he had recently inherited from his mother's sister and where I was treated like a princess. This unexpected deliverance I owed on the one hand to my beauty and on the other to my foster-mother who, without my knowledge or consent, had confided my family background to the captain.

Chapter 13

Tells of the delightful days and nights 'my lady countess' spent in the castle and how she came to lose them again.

In the castle I cosseted myself, like someone coming half frozen from cold water and toasting themselves by the stove or at the fireside. Like a war-horse in winter quarters feeding itself up so as to be rested for the coming summer's campaigning and fresh for action, I had nothing to do but stretch out on my straw. Soon I was sleek and well again and eager for my lover. He arrived even before the longest night was past, for he had no more patience than I to wait for the spring.

He came with four servants, but only one was allowed to see me, the one who had accompanied me there. It was unbelievable with what touching words he expressed his sympathy at my being made a widow, with what great promises he assured me of his faithful services and with what courtesy he declared that at Lutter I had taken him captive both body and soul!

'Most noble, most beautiful lady,' he said, 'fate has decreed that my body is free again, but for the rest I remain your slave, who has come to hear his sentence – life or death – from your lips: life, if you take pity on your poor prisoner and save him from death by comforting him with your compassion in

the prison of his love; death if he cannot win your love and favour, or is judged unworthy of that love. I consider myself most fortunate that you came, like a second, chivalrous Penthesilea, to carry me off, out of the tumult of battle, your prisoner. But when my physical release restored my supposed freedom, that was when my misery started, for I could no longer see her who still held my heart imprisoned nor, because of the two contending armies, had I any hope of ever seeing her again. As witness to my doleful misery I sent many a thousand sighs to my sweet enemy, and since all they met was the empty air I began to lose heart and would have . . .'

The lord of the castle went on in this vein for some time in his efforts to persuade me to do what I was itching to do as much as he was anyway. However, by that time I had learnt that people have little respect for anything they come by too easily, so I feigned indifference to his desires, complaining instead that I was his prisoner since I was not free to go as I pleased, but was kept in his power. I had to admit, I added, that of all the gentlemen in the world I felt most obliged to him, as he had saved me from those who had violated my honour. I further acknowledged that I owed him a debt of deepest gratitude for his honourable and praiseworthy deed. If however, I went on, I was expected to repay my debt with the loss of my honour – albeit under the guise of love – and had been brought to this place for that purpose, then I could not see what honour he expected from men of honour, nor gratitude from me for his praiseworthy action in rescuing me. I humbly begged him

not to besmirch his name with a deed he might soon come to regret, nor to mar his reputation as a gentleman who loved honour above all things with the infamy of having forced, in his own house, a poor, abandoned women etc, etc. And then I started sobbing as if I really meant it, according to the old rhyme:

> See a woman sob and cry
> Enough to melt the heart of any man.
> It's all pretence, a cunning lie –
> When she wants to shed a tear, she can.

In order to make him think even more highly of me, I went so far as to offer him a thousand imperial thalers ransom if he would allow me to return safely to my own people with my honour intact. To this he replied that his love was so strong he would not exchange me for the whole kingdom of Bohemia. Moreover, he added, he was not so far below me in family and rank that there would be much in the way of difficulties to a marriage between us.

We were like a pair of doves the keeper has locked in the dovecot to get them to mate. They strut and fret until they weary and come to terms. We were just the same. Once I thought I had resisted long enough, I submitted docilely to my young admirer – he was no more than twenty-two – taking his golden promises at face value and agreeing to everything he desired. Indeed, I agreed with him so well that he spent a whole month there with me. But no one else knew the reason, apart from the one servant and an

old housekeeper, who looked after me and had to address me as 'my lady'. I modelled my behaviour on the old adage:

A louse in your hair, a tailor on his mare,
A whore in the hall – three proud creatures all.

My lover came to visit me very often during that winter and I even think that, had he not been ashamed to do so, he would have hung up his sword. But he was worried about the reaction of both his father and the king, who was seriously involved in the war, although with little success. But he came so frequently, and so openly, that his father and mother finally noticed and, after investigating the matter, discovered what the magnet was he had concealed in his castle that kept attracting his weapons away from the war. Accordingly they instituted extensive enquiries about me and my background and were very worried that their son might throw himself away on me and get stuck with a woman who would bring little honour to their noble house. They were determined to prevent such a marriage, but also to proceed cautiously, without harming me or offending my relatives, in case what the housekeeper had told them was true and I was a count's daughter and their son had already promised to marry me.

The first step in this affair was a confidential warning from the old housekeeper that my darling's parents had learnt that their son kept a secret mistress whom he intended to marry against their wishes. This, she said, they could not allow since they had

already promised his hand in marriage to an extremely noble family. Their intention, therefore, was to lay hold of me, though what they then intended to do with me she could not say. The old woman's news gave me a shock but not only did I not show I was afraid, trusting in my lover's great love and sworn promises, I took it with a confident smile, as if the Great Mogul of India himself would, if not protect, then at least avenge me. Almost every week I not only received affectionate letters from my lover, each time they were accompanied by substantial presents. In reply I complained about what I had heard from the housekeeper and begged him to avert this danger and make sure nothing happened to bring discredit on me or my family. The end of the correspondence was that two servants in my lover's livery arrived post-haste with a letter telling me to go with them immediately to Hamburg where he would lead me to the altar publicly, whether his parents liked it or not. Once that had happened, he said, both his father and mother would have to accept it and make the best of a fait accompli.

I was packed and dressed in two shakes of a dog's tail and went with them, by day and night, first of all by sea to Wismar and then on to Hamburg, where the two servants slipped away and left me all the time in the world to look for a Danish gentleman who wanted to marry me. Only then did I realise disaster had struck and the deceiver had been deceived. I was told I should accept it quietly and be thankful that the noble bride had not been dumped in the sea en route. Even in the city, where I perhaps imagined I

89

was safe, my would-be bridegroom's family was powerful enough, they added, to get a person such as everyone knew me to be sent packing.

What should I do? My wedding plans, my hopes, my dreams and everything I had looked forward to had come tumbling to the ground. The intimate, affectionate letters I had sent to my lover from time to time had been passed on to his parents and they had concocted the replies in order to get me to the place where I was now stuck. My cupboard was gradually getting bare and that soon persuaded me to earn my daily bread by the sweat of my nightly exertions.

Chapter 14

What else Courage did and how, after the death of two troopers, she acquired a musketeer.

I don't know what my lover felt when he found I was no longer in the castle, whether he laughed or cried. I was sorry not to enjoy having him any longer and I imagine he would like to have had a few more cuts off the joint if his parents had not snatched the dish away from under his nose.

It was at about this time that Wallenstein, Tilly and Count Schlick overran Holstein and other Danish territories with a flood of imperial troops and Hamburg, along with other places, was forced to assist them with food and ammunition. This meant there were people coming and going all the time, and the same was true of my clients. Eventually I heard that my foster-mother was still with the army, but that all my baggage was lost, apart from a few horses, which badly upset all my plans. Hamburg suited me well and I could not have wished for better business, but I knew this boom would only last as long as there were soldiers around. I had, therefore, to see that I made other arrangements.

One of my regulars was a young trooper who seemed to be very charming, brave and not short of cash. I set out my snares for him and used every hunter's trick I knew until I had him in my net and so inflamed with love that he would happily have

eaten out of my hand. He promised to marry me, come hell or high water, and would have tied the knot there and then in Hamburg if he hadn't had to get his captain's consent first. This he obtained without difficulty when he took me to his regiment so that he was just waiting for the opportunity for the cere- mony to be carried out. In the meantime his fellow troopers were wondering how he had had the good fortune to acquire such a beautiful young mistress and most of them would have been happy to make my more intimate acquaintance. The men of this victorious army had been successful for so long and taken so much booty that they enjoyed an abun- dance of everything. They were so sleek and well fed that most of them, driven on by the desires of the flesh, spent more time trying to satisfy their lusts than looking for booty or foraging for supplies.

My bridegroom's corporal in particular liked to nibble forbidden fruits and made a regular profession of giving other men horns. He felt it would be a great stain on his reputation if he laid siege without gain- ing the stronghold. At that time we were encamped in Stormarn, a part of southern Holstein which had never known war so that there was still an abundance of everything, including food, of which we appointed ourselves masters, making the country folk our ser- vants, cooks and waiters. The feasting went on day and night and every trooper invited his comrades to eat and drink at his host's expense. My bridegroom followed suit, and that was when the corporal put into action his plan to get inside my shift.

While my bridegroom was carousing in his quarters

with two of his comrades – they had actually been
put up to it by the corporal – the latter arrived and
ordered him to go on guard duty by the colours so
that once he was gone he could amuse himself with
me. My bridegroom, however, saw through the trick
straight away and was unhappy with the idea of
someone else taking his place or, to put it plainly,
cuckolding him. So he told the corporal there were
others whose turn it was to do guard duty before
him. The corporal replied that he should stop argu-
ing and obey the order or he would soon make him
stir his stumps, for he didn't want to give up this
excellent opportunity of having me. This was pre-
cisely what my bridegroom was determined to deny
him and he resisted so long that the corporal eventu-
ally drew his sword to force him to go on guard duty
or to give him such a bloody lesson that in future
other troopers would know what obedience they
owed their superior. Unfortunately my darling took
this amiss. He had his sword out just as quickly and
gave the corporal a cut to the head that bled him of
his overheated and lecherous blood, ridding him of
all his lust so that I was certainly in no danger from
him any more. At the corporal's cries the two other
troopers went for my bridegroom with their blades,
but he immediately ran one of them through and
chased the other out of the house. This man returned
soon, bringing not only the surgeon for the wounded
but some more soldiers to take my lover and me to
the provost-sergeant, where he was bound and
chained hand and foot. They wasted no time on him.
A summary trial was held the next day and even

though it was crystal clear the corporal had only commanded him to go on guard duty in order to stand in for him in bed that night, my bridegroom was sentenced to be hanged and I, as the cause of the trouble, to be flogged simply in order to uphold military discipline. However, on our pleas the sentence was so far commuted that my bridegroom was to be shot whilst I was to be escorted out of the camp by one of the provost-sergeant's underlings and sent on a journey that was not to my liking at all.

However bitter the journey might be, there were still two troopers who thought they might sweeten it for me, and for themselves. Hardly an hour from the camp I had to pass through a wood and there they hid with the intention of giving me a warm reception. If truth be told, I have never been so particular as to refuse a man a ride if his need be great, but I strongly objected to these two scoundrels coming on me in my wretched situation and demanding with threats of violence that for which I had been expelled and my lover shot. So I resisted, for I could tell by the expressions on their faces that once they had had their way with me they would rob me as well. They went so far as to approach me with naked swords, as if I were an enemy, both to frighten me and to force me to comply with their wishes. Knowing that, with the spell that rendered me proof against all weapons, their sharp blades would be no worse than two sticks, I took out my daggers, one in each hand, and set on them so quickly one had a knife in his heart before he knew what had happened. His comrade was stronger and more cautious, so that

neither of us could get at the other. As we fenced, we
screamed and shouted. He called me a whore, a hag,
a witch and even a devil, whilst I responded with
rogue, rapist and any other like compliments that
came to my lips.

All this racket attracted a musketeer, who came
through the trees and stood watching our strange
thrusts and parries for a long time, not knowing
which one he should help. When we noticed him we
both begged him to save us from the other. As you
can well imagine, Mars much preferred to come to
the aid of Venus than of Vulcan, especially as I
promised him wonders and he was dazzled and per-
suaded by my outstanding beauty. He raised his
musket and aimed at the trooper, this threat making
him turn and run away fast enough to tear the soles
from his boots, leaving his lifeless comrade wallowing
in his blood.

Once the trooper had gone and we were alone
together, the young musketeer was struck dumb by
my beauty so that the only question he could bring
himself to ask was what quirk of fate had left me
alone with the trooper. So I told him exactly what
had happened with my bridegroom and the corporal,
and how I had been sent away and how these two
troopers, the dead one and the one who had run
away, had tried to rape a poor abandoned woman.
But as he had in part seen, I went on, I had defended
myself valiantly and now I asked him, having come
to my aid and saved my honour, to continue to pro-
tect me until I found safety with decent people,
assuring him I would not fail to reward him well for

his assistance. First the musketeer searched the dead trooper, taking all the valuables he found, which paid him well for his trouble, then we made off, almost faster than our legs could carry us. We were soon out of the wood and that evening reached the musketeer's regiment, which was preparing to set out for Italy with the forces under Collalto, Altringer and Gallas.

Chapter 15

The conditions under which they agreed to live together as man and wife, while remaining single.

If there had been a single honest vein in my body I could have done things differently and followed an honest course, for my foster-mother had found where I was and came to join me with two of my horses and some ready cash. She advised me to leave the wars and use the money I had safely invested to settle down and live peacefully in Prague or on my captain's estates. But with the heedlessness of youth I refused to listen to either reason or wisdom; the stronger the beer, the better I liked it.

My foster-mother and I were travelling with a man who sold provisions and drink to the soldiers of the regiment of my late husband, the captain who had been killed at Hoya. Because of him I was treated with respect, and I think I would have found another fine officer to marry if we had only been settled in quarters somewhere. But at a time when our army of twenty thousand men in three divisions was marching at full speed for Italy and had to force its way through Grisons, where there were a lot of obstacles, not many sensible officers were thinking of looking for a wife, and that meant I would have to remain a widow even longer. Moreover there were some who were too timid to talk of marriage to me and others who had certain misgivings, but because of the way I

97

had stuck by my previous husband they all considered me much too virtuous – more virtuous than I really was – to suggest any activities on the side.

A long fast was not for me, and the musketeer who had come to my aid in the affair with the two troopers had fallen for me in such a big way he could not rest, day or night, but was always hanging round me whenever his duties allowed. I could see what his problem was, but since he did not have the courage to put a proposal to Courage, my feeling for him was as much contempt as pity. However, my proud intention of marrying an officer or no one gradually changed. I observed the man we were travelling with and the daily profit he made from selling food and drink while many a brave officer was on short commons, and I began to think I might like to go into the same line of business myself. I took stock of the money I had with me and found that, with the fair number of gold coins I had left sewn into my bodice, I had sufficient capital to start up. The only thing stopping me changing from being a captain's widow to a purveyor of food and drink was that I still felt I would be demeaning myself. But once I had reminded myself I was no longer a captain's wife, nor had much likelihood of ever becoming one again, the die was cast and I started imagining myself selling beer at double what I had paid for it and generally indulging in worse sharp practice than any old Jew.

By the time the triple imperial army had crossed the high Alps and reached Italy, my admirer's love had also reached its peak, still without him having said a word of it to me. Once he came to the canteen

tent under the pretext of buying a mug of wine and he looked as pale and wan as a girl who has just had a child and doesn't know the father, nor where its milk or porridge is coming from. His sad expression and yearning sighs were his most eloquent speech and when I asked him what he wanted he plucked up his courage enough to answer, 'Oh, madam (for he was not allowed to call me 'Courage'), if I were to tell you what I wanted I would make you so angry you would either banish me from your sweet presence and not deign to let me see you ever again or you would rebuke me for my presumption, either of which would be enough to consign me to the grave.'

After that he fell silent and I replied, 'If one of those can kill you, then the opposite can bring you back to life. I am under an obligation to you for rescuing me from those men who wanted to rape me in the Vierlande between Hamburg and Lübeck and I am very happy for you to look your fill on me and hope that will restore you to health.'

'Oh my lady,' he replied, 'that is the whole paradox of the matter. It was when I first saw you that I was infected with the disease which will kill me if I do not see you any more. What a strange reward for saving you from peril!'

I said that I must be very ungrateful if I had repaid good with evil, but my musketeer replied, 'Do not say that.'

'What exactly is it you're complaining about, then?' I asked.

'About me, about my misfortune,' he answered, 'about my fate or my presumptuousness, about my

illusions or about – I don't know what! I certainly wouldn't say you have been ungrateful. I was well enough rewarded for my modest effort in frightening off the one remaining trooper threatening your honour by the valuables I took off his comrade, whom you yourself had already valiantly despatched to prevent him shamefully violating your honour. I am yours to command,' he went on, 'but I am in a state of confusion, which has me so confused that I cannot explain anything, neither why I am confused, nor what I want, nor what either of us has done wrong, much less my innocence or anything else that might help me. Most noble, most beautiful lady, I am dying because fortune and my lowly position do not permit me to show your Highness how happy I would be to be the least of your servants.'

I just stood there, flabbergasted to hear such a speech from a lowly, very young and, as he himself said, confused musketeer. It seemed, despite the occasional incoherence, to indicate a bright and lively mind whose love was worthy of being returned and who would be well suited to assist me in the business I was about to set up. Therefore I decided to put the poor soul out of his misery and said, 'My friend, firstly you say you are mine to command, secondly that you would be my servant if you could and thirdly that you will die if you cannot see me. That suggests you are deeply in love with me. Tell me what you would like me to do for you, for I would not want to appear ungrateful to the man who rescued me from those who were trying to rape me.'

'I would like you to love me in return,' said my

admirer. 'If I were worthy of that I would be the happiest man in the world.'

'As you have already admitted yourself,' I replied, 'your status is too lowly for you to occupy the position with me you desire and which you have indicated at length in your words. Have you any suggestion of what I might do to free myself from the accusation of ingratitude and you from your suffering?'

To this he replied that he left it entirely to me. To him I was more a goddess than an earthly being, and he was happy to accept anything I commanded, be it life or death, freedom or servitude. He accompanied this declaration with such gestures and expressions that I knew I had acquired a spaniel on a leash who would prefer to be throttled in my service than enjoy his freedom without me.

I continued what I had started, fishing while the waters were still troubled. And why not? Does not the devil himself, when he finds people in the same state as my lovesick musketeer, do all he can to ensnare them? I'm not saying this to encourage honest Christians to take an example from me and copy the cunning of the arch-enemy, but to show Simplicissimus, to whom alone these memoirs are addressed, what kind of woman it was he made love to. Keep listening, Simplicius, and you will learn that I played the same trick on you as you did on me in Griesbach, and to such good effect that you were paid back a hundredweight for a pound. I had got my admirer to a state where he readily agreed to the following conditions:

1. He was to get himself discharged from his regiment, for otherwise he could not be my servant and I had no intention of becoming a musketeer's wife.

2. He was to live with me, be as loving and faithful to me as any husband to his wife and perform his marital duty to me, as I to him.

3. The marriage was not to be celebrated in church unless I was pregnant by him.

4. Until then I was to remain mistress not only of the food, but also of my own body and of my servant in all respects, just as the man is usually master of his wife.

5. Consequently he was not to have the power to stop me, even less to give me black looks, if I should speak to other men or do things that usually made husbands jealous.

6. Since I intended to start selling food, drink and supplies, he was to be in charge of the business and work hard to supervise all its affairs, day and night, like a conscientious businessman; but he was to leave ultimate control, especially over the money and himself, to me and not only accept criticism from me for any failings, but change and improve. To sum up: people in general should assume he was the master, look up to him and call him that, but he must always bear in mind his duty towards me outlined above.

This was the agreement with each other that we signed.

A final, seventh point was that, in order to remind him constantly of his obligations, he had to agree that I would give him a special name, based on the first words of the first order I should give him.

Once we had been through these points and sworn to abide by them, I sealed the agreement with a kiss but didn't allow him to go any farther for the moment. Soon afterwards he had his discharge, while I had laid out my money to set up my canteen and store in another regiment. And then I started profiteering as if I had been born to the business.

Chapter 16

How Tearaway and Courage lived together.

My young man turned out to be excellent in everything for which I had taken him on. He kept so precisely to our agreement and was so obedient that I had not the slightest cause for complaint. If he could tell what I wanted from the expression on my face, it was as good as done. He was so head over heels in love with me that he heard, but did not hear, and saw, but did not see what he had in me and what I had in him, imagining rather that he had the most virtuous, faithful, sensible and chaste lover on earth. Of course my foster-mother, whom he greatly respected for my sake, was a great help to me in encouraging this belief. She was more cunning than a fox and more rapacious than a wolf; I couldn't say which was her greatest talent, making money or acting as a bawd. If I had some such piece of debauchery in mind but was reluctant to arrange it myself, because I wanted to keep my reputation as a decent, respectable woman, I could rely on her to set it up and be sure my wishes would be put into effect. Her conscience was as accommodating as the Colossus of Rhodes, which allowed the largest ships to pass between its legs without having to strike their sails.

Once I had a great itch to have a young nobleman, still an ensign, who had long indicated that he fancied me. On the day when I was overcome with this

lust we had just set up camp outside a village and my servants were out with the others gathering wood and fetching water. My 'husband', having just put up my tent and taken the horses out to graze, was fiddling around with the cart. I had told my foster-mother about my desire for the young ensign and she brought him along, even though the moment was not quite opportune. The first thing I asked him, so that my musketeer could hear, was whether he had money with him. He, assuming I was asking about payment for my services as a whore (if you'll excuse the expression), replied that he had, so I said to my 'husband', 'Tear yourself away from that cart and go and fetch the dappled grey from the grazing. The ensign here would like to try it out; he intends to buy it and pay cash.' So the good soul trotted off, to carry out the first order I had given him, and the old woman kept watch while we got down to business which was highly satisfactory on both sides. My husband found the dappled grey more difficult to catch than the ensign did me and arrived back at the tent exhausted and just as impatient as the ensign pretended to be at the long wait.

Afterwards the ensign turned this episode into a song, 'The Dappled Grey', beginning, 'Ah, could I but express my torment', which went round the whole of Germany over the next few years, although no one knew its origin. And following our agreement my 'husband' was nicknamed 'Tearaway', the same Tearaway whom you, Simplicius, repeatedly praise in your memoirs as a good chap. You should also know that he learnt all the ruses you and he practised in

Westphalia and Offenburg, and many more besides, from none other than me and my foster-mother. When I took up with him he was as naive as a little lamb and when we separated he was more cunning than a lynx or an arch-villain.

To tell the truth, his education did not come free, he had to pay dearly enough for it. Once, while he was still naive and ingenuous, my foster-mother and I were discussing the malice and deceit of women with him and he was stupid enough to boast that no woman would deceive him, no matter how cunning she was. Even though in saying this he was only demonstrating his own simplicity, I objected to him disparaging my skill, and that of all intelligent women, so I told him straight out that if I wanted I could deceive him nine times over before he had even eaten his breakfast bowl of soup. He then had the cheek to say if I could do that he would be my bond-slave for the rest of his life and positively defied me to do it, adding a condition of his own, namely that if I did not succeed in deceiving him even once I was to go with him to the church and make an honest man of him.

We agreed on the terms of the bet and the next morning I came in with some bread in a soup bowl, carrying a knife and whetstone in the other hand, and asked him to sharpen the knife so that I could cut up the bread for his soup. He took the knife and stone and then, because he had no water, licked the whetstone to moisten it. At that I said, 'As God's my witness, that's twice!' He looked baffled and asked me what I was talking about, so I asked him if he

had forgotten the bet we had made the previous day. He said no and asked me whether I had already deceived him, and in what way?

'Firstly,' I replied, 'I deliberately made the knife blunt so you would have to sharpen it and secondly I dipped the whetstone in a place which you can well imagine, before giving it you to lick.'

'Yeuch!' he said. 'If that's the kind of thing you're going to get up to then you can stop now. You've won. I've no desire to find out what the other seven are.'

So I had a bondslave in my Tearaway. At night, if I had nothing better, he was my husband, during the day my servant, and when other people could see him, my lord and master. He adapted both to the business and to my moods so well I could not have wished for a better husband. Indeed, I'd have been more than happy to marry him, only I was worried that if I did he would throw off the yoke of obedience and, insisting on the mastery which would be his legal right, pay me back a hundredfold for everything he had had to put up with from me, doubtless much to his annoyance, while we were not married.

Meanwhile we lived together in harmony, in a kind of wedlock, if not quite holy. My foster-mother looked after the buying and selling in my place, while I played the part of the pretty cook or waitress the landlord keeps behind the bar to attract as many customers as possible; and my Tearaway was servant and master and anything else I wanted him to be. He had to obey me without question and do as my foster-mother told him, but otherwise he was master

to all my servants, and I had more than many a captain in the regiment.

The army butchers in that regiment were a dissolute lot who were better at pouring their money down their throats than earning it, and this enabled me to bribe my way into the trade. I started out with two apprentice butchers, gradually taking over and ruining the others because I could provide any of my customers, wherever they came from, with a piece of whatever type of meat they desired: raw, stewed, roasted, or living flesh. When there was a chance of robbing, stealing or plundering (Italy was rich and full of fine booty) not only did Tearaway and all my servants have to risk their necks, but Courage herself went back to the trade she had plied so well in Germany. What with robbing the enemy at swordpoint and fleecing my friends in camp with my prices – and being well able to defend myself if anyone tried a little friendly persuasion – my purse swelled so much that almost every month I had a bill of exchange for a thousand crowns to send to Prague, and at the same time neither I nor my assistants went short for anything. I did everything to make sure my foster-mother, Tearaway, my other servants and, above all, my horses always had food and drink, clothes and shelter, and would have done so even if it had meant going hungry and naked myself and spending my days and nights out in the open. In return they had to work hard to bring in the money, not resting day or night, even at risk of their lives.

Chapter 17

The embarrassing trick that was played on Courage and the revenge she took.

As you see, my dear Simplicius, I was already mistress and mentor to your crony Tearaway while you were probably still looking after your Da's swine, before you had even learnt enough to play the fool for your master. And you imagined you were the one who duped me in Griesbach!

After the first siege of Mantua we went into winter quarters in a lively little town where I started to get quite a lot of custom. There was no banquet or orgy where Courage was not invited, and wherever she appeared the Italian *puttane* counted for nothing. To the Italian men I was a tasty, exotic dish, to the Germans someone who spoke their own language, to both I made myself as agreeable as could be and I was decidedly beautiful into the bargain. I wasn't arrogant or expensive, and no man needed to worry about being fleeced by me, as was the case with most Italian whores. Given this, I took many a good customer away from my local rivals, which hardly endeared me to them.

Once I was invited to dine by a noble gentleman who until then had patronised the most celebrated courtesan but now abandoned her for me. Determined to recapture her milch-cow, she got a furrier's wife to slip me something during the meal that made

my belly swell up fit to burst. The pressure of gas grew so great it eventually forced its way out and everyone at the table heard its dulcet tones, making me blush for shame. As soon as the other diners had managed to open the door, they thundered out with the sound of several batteries of artillery letting off a salvo at once. When I then got up to leave, the exertion set the eruptions going in earnest. At every step I let out at least one, or perhaps ten, they came so quickly no one could count them. If I had been able to control them and discharge them at will I believe I could have beat the retreat for two whole hours better than the best drummer. As it was, it only lasted half an hour, during which time the other guests and the waiters laughed so much they suffered even more than I did from my continuous trumpeting.

I was mortified at this trick that had been played on me and wanted to run away and hide my head in shame. My escort felt the same, for when he invited me he had had a quite different performance in mind from the wind concert I had given. He swore by all that was holy he would avenge the affront if only he could find out which purveyor of peppercorns and ants' eggs was responsible. Since, however, I was wondering whether he wasn't the instigator himself, I just sat there glowering, as if I wanted to strike everyone dead with the angry flashes from my eyes. Eventually one of the other men present told me that the furrier's wife knew about these things, and since he had seen her in the building he could only assume she had been hired by some jealous lady to

use the device to put this or that gentleman off me. It was known that she had done the same to a rich merchant who had been discarded by his beloved after having played the same trumpet voluntary in respectable society. At that I snapped out of my sulks and started trying to think up a rapid revenge. It should not be too public, nor too cruel because we were expected to maintain order in our quarters, quite apart from the fact that we had seized the country from the enemy.

Once I had confirmed that it was as my fellow diner had said, I made it my business to find out everything I could about the habits of the lady who had played the trick on me. I discovered she used to hold audience from a window at night with those who wanted to go up to her, so I told two officers about the grudge I held against her and made them promise to carry out my revenge if they wanted to continue to enjoy my favours. Since she had embarrassed me with the mere smell, I thought it only right and proper I should repay her with the excrement itself. And this is how I went about it. I had a cow's bladder filled with the worst ordure the cleaners appointed by the privy council could dredge up. This was tied to the kind of stick people use for knocking nuts off trees or sweeping the chimney, and on a dark night, while one of the officers was flirting with the whore at her audience window, the other hit her in the face with it so hard that the bladder burst and the contents went all over her nose, eyes, mouth and breast, as well as her jewels and finery. Both of the officers, her 'admirer' and the

perpetrator, immediately made off, leaving the whore at the window to squawk for as long as she liked.

I paid back the furrier's wife in the following way. Her husband was in the habit of keeping every little hair, even if it were one of the cat's, as if he had shorn it from the golden fleece in Colchis. He took this habit so far that he wouldn't dream of throwing away the tiniest scrap of skin without first removing all the hair or wool, whether it was beaver, hare or lamb. Whenever he had collected a pound, the hat-maker gave him some money for it, from which he could buy something to add a little body to his soup. It wasn't much and it was a long time in the gathering, but it was still welcome.

All this I had from another furrier who was lining a fur for me during the winter. I got as much wool and hair from him as I needed and used it for lav-atory paper. When I had finished with it and the tufts were more thickly smeared with waste matter than an apothecary's pots with ointment, I got one of my boys to scatter them round the furrier's privy, which was easily accessible. When the cheeseparing furrier saw these clumps of hair and wool lying there he thought they were his own and naturally assumed it was his wife who had soiled and ruined them. He started to swear and shout at her, as if she had lost both Mantua and the fortress of Casale, and since she denied it as obstinately as a witch and answered back as well, he gave her such a tanning as he normally reserved for the pelts of wild animals, not to mention the skin of the odd domestic cat. I was so pleased at

the success of my stratagem that I wouldn't have missed it for twenty crowns.

That left the apothecary who, I guessed, must have concocted the recipe that made me raise such an uncontrollable voice from my nether parts. He kept songbirds, which he fed on the things that were claimed to produce the noises I described earlier. However, since he was highly regarded by all the officers, both senior and junior, and was daily in demand for the men in the sick bay who could not stand the Italian air, also bearing in mind that I might need his services myself any day, I could not afford to get on the wrong side of him. Nevertheless I was determined to give him a dose of his own medicine and wreak vengeance on him for the reek his prescription had caused me to let off.

He had a small vaulted cellar next to his house where he stored all kinds of goods that needed to be kept in a cool place. I took a long piece of ox's intestine, attached it to the pipe of the well, which was on the square beside the house, and used it to direct the water into the cellar all through a long winter's night. In the morning the cellar was full to overflowing. There were little casks of malmsey, Spanish wine and similar things floating round, while the heavier objects were being ruined below six feet of water. Since I removed the piece of intestine before daybreak, everyone assumed a spring had broken through into the cellar or that the trick had been played on the apothecary by magic. I, of course, knew the truth and laughed up my sleeve when I heard him bewailing his ruined stock. And that was

the first time I was glad the name 'Courage' was so widely known, otherwise the men would surely have appointed me Fartmistress-general because I outperformed everyone in that art.

Chapter 18

How Courage abandoned both God and her conscience.

The money I made from all my various enterprises gave me such pleasure that the longer things went on the more I wanted. Already it was all the same to me whether I acquired it by honourable or dishonourable means, and now I was no longer concerned whether I served God or Mammon to get it. It came to the point where I dispensed with my conscience entirely; I couldn't care less what tricks, ploys or practices I used as long as I lined my pockets. My Tearaway had to become a horse-coper, and anything he didn't know I taught him, for I had a thousand pieces of chicanery and underhand dealing I used in that profession. No article, whether gold, silver or jewelry, not to mention pewter, copper or cloth, whether clothing or anything else, whether legal booty, plunder or even stolen goods, was too expensive or too cheap for me to trade in. And if a man didn't know what to do with the things he had to sell, however he had acquired them, he was as safe with me as with the Jew, for we were both keener to protect thieves than to have the authorities punish them. As a result, the contents of my two carts were more like a general merchant's stock than just a victualler's and I could supply anything – at a price – to any soldier, high or low. On the other hand I had to wet quite a few whistles and grease quite a

few palms to safeguard myself and my activities: the provost-sergeant was like a father to me, his old woman (his wife, I mean) like a mother; the colonel's wife was 'my lady' and the colonel 'my lord', and they all protected me and mine, and made sure nothing happened to harm my business.

Once an old sweat – I mean an old soldier who had joined the colours long before the troubles in Bohemia started – brought me something enclosed in glass which wasn't quite a spider, nor quite a scorpion. I could tell it wasn't an insect or some other living creature, because there was no way for air to get in through the glass. I assumed it was a piece made by some outstanding master craftsman as an allegory of perpetual motion or whatever, because the thing in the glass was constantly moving and crawling around inside. It looked valuable to me and since the old man was offering to sell it I asked how much. Two crowns was what he wanted for the bauble and I immediately handed them over. I also offered him a mug of wine, but he said he had already been paid enough. This surprised me in an old soak like him, so I asked him why he had refused the wine, which I usually included in any transaction.

'Ah, Frau Courage,' he said, 'this is not like other goods. There are particular rules about buying and selling it and when you dispose of this little gem you must make sure you let it go for less than you paid for it.'

I replied that in that case I would not make much on it, to which he answered, 'That's your problem

118

now. As for me, I've had it for thirty or more years and not lost anything by it, even though I bought it for three crowns and sold it for two.'

I couldn't make head nor tail of all this, or perhaps I didn't want to. However, as I expected to get pretty merry that evening (I would have to service several horny males), it was the least of my worries and, anyway, I didn't know what to make of the old gaffer. He didn't seem to be the kind of man who would have the nerve to try and swindle Courage. Also, I was so used to people who looked more reputable than him selling me things for a ducat that were worth a hundred that I felt happy with my prize and stuck it in my pocket.

The next morning, after I had slept off the effects of the drink, I found my bargain in my trouser pocket (you should know that I always wore trousers underneath my skirt). I remembered immediately the details of the purchase and put it with the other rare objects, such as rings and jewels, that I took a fancy to and was keeping safe until I came across someone who knew about art and could value them for me. However, during the day when I happened to look in the sack again, I found it wasn't where I'd put it, but back in my trouser pocket. This surprised rather than frightened me, but it did make me keen to know what it was, and so I set out looking for the man who had sold it to me. When I found him I asked him what it was he'd sold me, telling him the strange thing that had happened with it.

'It's a familiar spirit, Frau Courage,' he replied. 'It brings great luck to the person who buys it and

carries it with him. It tells its owner where hidden treasure lies buried, brings enough customers for any business he has, increases his prosperity and makes him loved by friends and feared by enemies. It makes anyone who possesses and trusts it as bullet-proof as steel, and they are never sent to prison. It brings good fortune and victory, helps its owner overcome enemies and makes him loved by almost everyone.'

In short, the old rogue piled it on so much I imagined myself happier than Fortunatus with his magic sack. However, I could well imagine this spirit would not give its services for nothing, so I asked the old man what would be expected of me. I had heard, for example, that magicians who take on the shape of a gallows-wight to rob people have to wash and groom the gallows-wight once a week. The soldier replied that this was not necessary; the thing I had bought from him was quite different from a gallows-wight. But it would not want to be my servant and do my bidding for nothing, I insisted, and told him to come right out and tell me whether I could keep it without danger and without having to reward it, and enjoy its services without having to do anything in return.

'You already know, Frau Courage,' he said, 'that when you've finished with it you have to sell it at a lower price than you gave for it. I made that clear when you bought it from me. However, you must get someone else to tell you the reason.' And with that he went on his way.

At that time my Bohemian foster-mother was my closest adviser, my confessor, my confidante, my best

friend. I told her everything, including what had happened with the glass I had purchased. 'Hey,' she said, 'that's a stirpitus flamiliaris that is, it'll do everything the man who sold it you said it would. The only trouble is that anyone who keeps it until they die has to go to the other world with it, and from its name that must surely be hell, which it is full of fire and flames. That's why it has to be cheaper every time it's sold, so that the last purchaser gets stuck with it. You're in great danger, my daughter, because you're the last one who bought it. Who do you think'll be stupid enough to buy it from you if he knows he's not going to be able to sell it, if he knows that with it he's purchasing his own damnation?'

I could see I'd made a bad bargain, but I was young and carefree and expected to live a long time yet; the world around me paid no heed to God and so I made light of the danger. I thought to myself, 'Make the most of this little talisman for as long as you can. You're sure to find some devil-may-care fellow who'll take the thing off you at the right price, either because he's drunk or penniless, desperate or blindly hoping to make his fortune, out of greed, lust, anger, desire for revenge or something of the kind.'

From then on I used the charm to the full, just as it had been described by both the man who sold it and my foster-mother. And I noticed the effect daily. Where other canteens sold one cask of wine, I was broaching three or four; once a customer had tasted my food or drink he always came back again; no

sooner had I seen a man I fancied making love to than he was at my feet declaring his passion, almost idolising me. Whenever I came to quarters whose owner had fled, to an abandoned cottage or hovel where no one else could live (the army is not in the habit of housing its victuallers and butchers in palaces), some inner voice led me straight to the place where treasures were hidden which had not seen the light of day for perhaps a hundred years. On the other hand I cannot deny that there were those who would have nothing to do with Courage, who despised rather than respected her and even spoke out against her, doubtless because they were illuminated by a greater light than my 'stirpitus flamiliaris'. This did make me think, did make me reflect on the why and the wherefore, but by that time I was so addicted to money and all its attendant vices that I left things as they were and would not have dreamt of getting rid of the foundation of all my happiness. My pile of money simply grew and grew until it was so large it even frightened me.

I'm telling you all this, Simplicius, to show up your self-praise in its true light, because you boasted in your memoirs of having had a lady in Griesbach, yet knew nothing at all about her. And there's another thing I must point out. If you had any sense at all you would no more have let yourself be ensnared by me when we were making love at the spa than those who were protected by God while I had my familiar spirit.

Chapter 19

Tells of the school Tearaway was put through until he was the finished article.

And there's another thing you should know, Simplicius. I wasn't the only one who went on my merry way regardless. My Tearaway, whom you describe as your best friend and an 'honest fellow', had to follow me. And what would there have been to stop him? It would have been one of the wonders of the world if he hadn't. There are lots of other loose women like me who induce (I won't say 'force') their dissolute men (perhaps I should just say 'men' and call the minority 'pious men') to take part in similar criminal activities, even though they haven't drawn up the same kind of contract as Tearaway and I did. Listen to this story:

While we were encamped outside the famous fortress of Casale, Tearaway and I went to a neighbouring city, which was neutral, to buy provisions. I used such occasions not only to haggle like an Israelite, but to hawk my wares like a Cyprian maiden. I had decked myself out like Jezebel and didn't care who I seduced. For this purpose I went into a church, for I had been told that in Italy most affairs were started and arranged in such sacred buildings because beautiful women, who might attract a lover, are not allowed to go anywhere else. I happened to be standing next to a young lady and was at once jealous of

her beauty and jewelry because of the man who was giving her loving looks instead of gazing at me. I have to admit I was piqued to think that she should be preferred to me, that a prospective client should reject me – or so I assumed – for her. My prayers during the service concentrated entirely on my annoyance and plans for revenge.

Tearaway turned up before mass was over. What made him come I have no idea but I can hardly believe it was the fear of God. He wasn't naturally godfearing and I had made no effort to encourage him in that direction, nor did he ever read the Bible or listen to sermons. Nevertheless, he appeared in the church beside me and received a whispered command to make sure he found out where the lady lived so that I could get my hands on the beautiful emerald she wore at her neck.

He carried his task out faithfully, like the true servant he was, and returned with the information that she was the noble wife of a rich gentleman who had a fine house on the market-place. I then made it clear to him that if he wanted to stay in my good books and touch my body ever again he had to bring me that emerald, for which I would provide a foolproof plan as well as the means and opportunity. He scratched his head a bit and declared it was impossible, but after a lot of humming and hawing he announced he was ready to die for me if necessary.

So you see, Simplicus, that was how I trained Tearaway like a young spaniel. He had the natural talent, perhaps more than you, but he would never

have become such a paragon if I hadn't licked him into shape.

Just at that time I had to have a new handle made for my heavy hammer, which I used both as a weapon and a key to open the farmers' chests and cupboards. I had the handle hollowed out, wide enough to take ducats or lower-value coins of the same diameter. Since I always had this hammer with me, not being allowed to wear a sword and not wanting to carry a brace of pistols, I had the idea of filling the hollow handle with ducats, which I would always have to hand, so to speak, ready for any turn of fortune or misfortune, both of which are common in times of war. Once it was finished I tested the size with some Swiss coins I had accepted in payment with the intention of exchanging them. The hollow in the handle had the same diameter as the coins, so the fit was a little tight and I had to use some force to push them in, though by no means as much as if I were loading a demi-culverin. I didn't have enough to fill the handle, which turned out to be rather nice, because if they were at the top and I took hold of the head, to use the hammer as a walking stick, some of the coins would tumble down, making a dull clunking noise, which sounded odd because no one knew where it came from. Why all this lengthy description? I gave the hammer to Tearaway, together with instructions as to how he was to use it to get the emerald for me.

Tearaway disguised himself with a wig, wrapped himself up in a black cloak we had borrowed and spent two whole days doing nothing but stand opposite the lady's house, scrutinising it from cellar to roof,

as if he intended to buy it. I had also hired a drum-
mer who was so sharp you had to be careful you
didn't cut your finger on him. All he had to do was
wander round the square, keeping an eye on Tear-
away in case he needed him, because the little rogue
could speak Italian as well as German, which Tear-
away could not. I had got an alchemist to make up a
solution that eats through any metal in a few hours,
making it crumble or even dissolving it entirely, and I
brushed it on the bars over the cellar-light.

On the third day, as Tearaway was still staring at
the house, like a cat eyeing a new barn door, the lady
sent out to ask why he was standing there all the
time and what it was about her house he was trying
to find out. Tearaway called over the drummer to
act as interpreter and told her there was a treasure
hidden in the house he not only believed he could
find, but which was enough to make a whole city
rich. At that the lady invited both Tearaway and
the drummer in. After she had once more heard his
story of the hidden treasure and been fired with
determination to find it, she asked the drummer
about Tearaway, whether he was a soldier or what?

'No,' replied the little rascal, 'they say he's really a
sorcerer and only joined the army to find hidden
goods. I've been told that in old castles in Germany
he's found iron chests and cupboards full of money.'
That, he added, was what he'd heard, he didn't know
Tearaway personally.

In short, after a lot of discussion it was agreed
that Tearaway should look for the treasure. He asked
for two consecrated candles. He himself lit a third,

which he had with him and which had a brass wire running inside by which he could put it out whenever he wanted. Her husband not being at home, the lady and two of her servants went round the house with Tearaway and the drummer, shining the candles everywhere because Tearaway had told her that his candle would go out when they came to where the treasure was. This procession visited all sorts of nooks and crannies, and at every place they shone their candles Tearaway mumbled strange words, until they reached the cellar where I had painted the iron bars with my aqua regia. Tearaway stood facing a wall and, going through his usual mumbo-jumbo, pulled the wire and put his candle out.

'There! There!' he told the lady, the drummer translating. 'The treasure's been bricked up in the wall.' Then he muttered some gibberish and hit the wall several times with the hammer. At each blow some of the coins rolled down inside the handle, making their usual noise. 'Did you hear that?' he said. 'The treasure's ripe for picking. It only happens every seven years, it's time to lift it, while the sun's still in the sign of the hedgehog, otherwise you'll have to wait another seven years.'

The lady and her servants would have sworn on their mother's grave that the clinking noise came from behind the wall, so they believed every word Tearaway said. The lady asked him to lift the treasure for a fee and wanted to agree a sum with him there and then. He, however, replied that in such cases he made no demands, but only took whatever

people willingly gave him, at which the lady assured him he would be well pleased with her gratuity.

He asked for seventeen grains of choice incense, four consecrated candles, eight ells of finest scarlet cloth and four precious stones – a diamond, an emerald, a ruby and a sapphire – which the lady had worn at her neck both before and after her marriage. After that they were to lock him in the cellar, the lady keeping the key so that she could be sure her cloth and precious stones were safe and he could go about retrieving the treasure undisturbed and unobserved. While these things were being gathered together the two were given a snack. Then Tearaway was locked in the cellar, from which it seemed impossible for any man to escape, given that the one window onto the square was high up and barred. The drummer was dismissed with a tip for his services as interpreter and came straight to me to tell me what had happened.

Neither I nor Tearaway slept through that best hour of the night when people are in their deepest sleep. I broke the bars as easily as if they had been turnip chips, let down a rope to Tearaway and pulled him up together with all his treasure-retrieving paraphernalia, including the beautiful emerald I wanted.

I was more pleased at the success of my scheme than at the loot itself. The drummer had already left the town the evening before, but the day after the treasure had been lifted Tearaway walked round the town with some comrades, expressing their amazement at the cunning of the thief even while the

authorities were putting a guard on the gates to try and catch him.

So you see, Simplicius, I was the one who trained your Tearaway in his chicanery. I am just telling you this one trick he played as an example. If I were to relate every piece of knavery and thievery he had to carry out at my behest, I'm ready to bet both of us would eventually find it tedious, even though they are amusing in themselves. If I were to recount everything the way you describe all your silly pranks it surely would be a longer and more amusing book than the chronicle of your life. However, I will give you just one more instance.

Chapter 20

How Tearaway and Courage robbed two Italians.

When we realised we would be camped outside Casale
for a long time, many abandoned their canvas tents
for huts of different materials which were better
suited for a lengthy stay. Among the other dealers
were two Milanese who had built themselves a hut of
planks so that their goods were more secure. They
sold shoes, boots, jerkins, shirts and other clothes, for
both officers and men, cavalry and infantry. I felt
they harmed my own business because they bought
all kinds of silver and jewels from the soldiers at half
or even a quarter of their value, and some of that
profit would have come to me if they hadn't been
there. It wasn't in my power to stop them trading, so
I decided at least to cream off a share of their profits.

The ground floor of the hut was where they kept
their goods, and it also served as their shop. They
slept under the roof in the attic with seven or eight
stairs leading up to it. They left an open hole in the
ceiling of the shop so that they could hear if robbers
were breaking in to steal their goods; it also allowed
them to give any thieves a warm welcome with their
pistols, with which they were well provided.

Once I had observed that their door could be
opened without making much noise my plan was
easily made. Tearaway had to bring a bundle of
branches with sharp thorns, as tall as a man and

almost as much as a man could carry, while I filled a pint-sized brass syringe with sharp vinegar. Thus equipped, we went to the hut, when everyone was fast asleep. Opening the door quietly was no problem since I had checked it out carefully beforehand. Once that had been done, Tearaway stacked the bundle of thorns at the bottom of the stairs, which had no separate door. The noise he made woke the two Italians, who started clattering about above. We were sure the first thing they would do would be to peer down through the hole, and when they did, I squirted so much vinegar into the face of one of them he was blinded in the twinkling of an eye; the other came charging down the stairs in his nightshirt and drawers, landing right on the pile of thorns. In the unexpected shock, both assumed there was magic or devilry at work. While all this was going on, Tearaway had grabbed a dozen cavalry jerkins. I contented myself with a bolt of linen, slipped out with it and shut the door behind me, leaving the two Italians to their woes, the one doubtless still wiping his eyes, the other picking the thorns out of his feet.

That was me, Simplicius, and that's the way I gradually trained Tearaway. As you heard, I didn't steal from need, but often to do my business rivals down. And Tearaway applied himself to the art until he was such a master that he would venture to steal anything, even if it were chained to the firmament. And I let him enjoy the fruits of his labours. He had his own sack and could do what he wanted with his portion of the stolen goods, which we shared out

fifty-fifty. Since, however, he was addicted to gambling, he never had much money. Even if he occasionally managed to amass the beginnings of a tidy sum, he could never keep hold of it for long, since lady luck was constantly nibbling away at the foundations of his fortune through the fickle dice. For the rest, he remained loyal and obedient to me, so that I couldn't have found a better slave in all the world.

Now hear what he got out of it, how I rewarded him and how I eventually parted from him.

Chapter 21

The story of an affray that took place during sleep.

Shortly before the imperial army took Mantua, our regiment had to leave Casale and reinforce the troops besieging the city. There business was brisker than in the previous camp, for there were more men there, especially Germans, so that I had more customers and more customer service to perform. As a result, my moneybags swelled noticeably quicker and I sent several bills of exchange to Prague and other German imperial cities. In view of the money coming in daily and the prosperity and abundance we enjoyed, while others were going hungry, Tearaway started behaving like a young lord. He wanted to do nothing but eat and drink, gamble and stroll around; in short, to be idle and leave our canteen and store, and any other opportunities to turn an honest – or dishonest – penny, to look after themselves. More-over a number of good-for-nothings and wastrels had attached themselves to him and led him astray so that he was no use any more for the things I had taken him on and trained him up for.

'Huh,' they would say, 'you're a man and you let your whore lord it over both you and your money? I could understand it if you had a crabby wife and were forced to put up with it. If I was in your shoes, I'd give her a good thrashing until she toes the line or send her to the devil . . . etc, etc.' I learnt all this soon

135

enough and it didn't please me one bit. I started thinking of ways to get my Tearaway to tear himself away from me without him or his drinking companions noticing I was the one who'd set things in motion. My servants, including four strong lads, were loyal and on my side, all the officers were reasonably well disposed towards me and the colonel, even more the colonel's wife, looked kindly on me. To put them under further obligation, I showered gifts on all those from whom I hoped for aid in the imminent domestic war which I expected Tearaway to declare at any moment.

I knew full well that Tearaway, as the man, was regarded as the head of my canteen business, and even though it was only for appearances' sake and I was the one who ran it behind the scenes, I also knew that it would be goodbye to the business the moment I lacked such a figurehead. For that reason I had to proceed very carefully. I gave him money every day, both for gambling and drinking, not to persuade him to return to his former sensible behaviour, but to hoodwink him into thinking he could take what liberties he liked with me so that he would do something stupid, commit some outrage that showed he was unworthy of possessing either me or my worldly goods. In a word, I wanted to make him give me cause for a formal separation. I had already amassed so much, and deposited it in safe places, that I did not need to worry about the business or the wars and what further profit I might squeeze out of them.

I don't know whether Tearaway didn't have the guts to follow his friends' advice and demand my

submission publicly or whether he was just happy
to continue his dissolute ways. He was as friendly
and submissive as ever and never gave me so much
as a dark look, much less an angry word. I knew
very well what his cronies were egging him on to do,
but his behaviour towards me did not suggest he
had any intention of carrying it out. Eventually,
however, there was a strange incident in which he
gave me justified cause for complaint which led to
our parting, whether he wanted or not.

Once, after he had come home drunk, I was lying
next to him, fast asleep and all unsuspecting, when
he suddenly hit me in the face with all his strength.
It not only woke me up, it sent the blood pouring out
of my nose and mouth and so dazed me I was sur-
prised it hadn't knocked all my teeth down my
throat. You can imagine the tirade of abuse I gave
him; murderer was the least of the terms I threw at
him.

'Come on, you walking dungheap,' he said, 'why
don't you let me have my money? It was fairly got.'
He tried to hit me again so that I had my work cut
out trying to defend myself and we ended up sitting
on the bed wrestling. He kept on demanding money
from me so I gave him a good box round the ears
that laid him flat again. Then I dashed out of the
tent and set up such racket it not only brought out
my foster-mother and the other servants but woke
the neighbours, who came scrambling out of their
huts and tents to see what was going on. These
were all staff from the regimental office, who were
normally lodged in the same part of the camp as the

victuallers, namely the chaplain, the quartermaster, the intelligence officer, the commissary, the provost-marshal, the executioner, the whoremaster and the like. I went on at great length, supported by my appearance, about how my fine man had treated me, completely without provocation. My milk-white bosom, taut against the material of my nightdress, was spattered with blood and one blow of Tearaway's fist had made such a mess of my face, usually so alluring, that they could only recognise me by my plaintive voice, even though no one there had ever heard me complain before.

They asked me the cause of the quarrel and ensuing fight, and when I told them what had happened everyone there thought Tearaway must have gone out of his mind. I, however, assumed he had done it at the instigation of his cronies and drinking companions in order to get control of me, my business and my money. While we were standing there talking and some of the women were trying to staunch the bleeding, Tearaway crawled out of our tent. He came over to us at the watch fire by the colonel's baggage and could not say enough to ask both my and everyone else's pardon for the trouble he had unwittingly caused. Much more and he would have been down on his knees before me begging my forgiveness and to be taken back into my good graces. But I turned a deaf ear to his pleas and refused even to listen until the lieutenant-colonel came from his rounds. Tearaway offered to swear a solemn oath that he had dreamt he was at the square used for gambling where someone had tried to cheat him out of his stake and winnings.

That was the person he thought he had been hitting, he said, and it was only unintentionally that he had struck his dear, innocent wife in her sleep. The lieutenant-colonel was a gentleman who hated me and all whores like the plague, but was quite favourably disposed towards Tearaway. He told me to clear off back to my tent with Tearaway and keep my trap shut or he would have me hauled up before the provost-sergeant and given the proper thrashing I had long deserved.

'By Christ,' I thought to myself, 'that's a harsh sentence. I wouldn't want to meet too many judges like you. But it doesn't bother me, even if you are a lieutenant-colonel and proof against both my beauty and my bounty. There are plenty of others, and more than your sort, who are quite happy to let themselves be persuaded to take my side.'

I didn't breathe a word of this, of course, and Tearaway held his tongue when the lieutenant-colonel told him that if he ever did it again he personally would see to it that he got one flogging in broad daylight which would be more than enough punishment for what he had twice done to me during the night and would certainly make sure he didn't do it a third time. He told us both to make our peace before sunrise, otherwise he would send an arbiter round to us in the morning whose methods would certainly give us something to think about.

After that we went back to bed, both nursing our bruises, since I had given Tearaway as good as I got. He kept swearing blind it had all been a dream, but I told him dreams were mere imaginings, but there had

been nothing imaginary about the punch I'd had in the face. He tried to give me physical proof of his love but because of the blow, or more probably the fact that I wanted to get rid of him, he could not arouse the least spark of desire in me. The next day I didn't give him any money for gambling or for drinking, nor any encouraging looks or words. And to make sure he didn't get his hands on the cash I kept as a float for the business, I concealed it on the person of my foster-mother, who had to go round, day and night, with it sewn into her clothing next to her skin.

Chapter 22

What led to Tearaway and Courage's separation and her parting gift to him.

A short while after our nocturnal battle, Mantua was taken by a subterfuge and it was not long before peace itself broke out between the Empire and the French, between the dukes of Savoy and Nevers, just as if our clash had signalled the end of the Italian campaign. The French left Savoy and hurried back to France while the imperial troops went to Germany, to see what the Swedes were doing there, and I had to leave with them, just as if I were a soldier. For a few weeks, either to recuperate or because there were many cases of dysentery and even the plague, our regiment had to camp out in the open by the Danube in Austria. I certainly missed the comforts of life in Italy, but I made the most of what there was. I also made peace with Tearaway, who was more submissive than a whipped cur, though I did so only for the sake of appearances. I was constantly on the look-out for an opportunity to get rid of him.

My wish was fulfilled by an episode which demonstrates how a cautious, sensible, even innocent man, who when he is sober and alert is more than a match for anyone, man, woman or devil, can easily be plunged into misfortune by his own weakness when he is drunk with wine and sleep, and forfeit both happiness and well-being.

Just as the least affront or imagined insult would make me seethe inwardly with rage and desire for revenge, so the least tap left a livid mark on my body, though I couldn't say whether that was my body taking its cue from my mind, or whether my skin was so delicate it couldn't take the same blows as a Salzburg lumberjack. However that may be, in the camp by the Danube my two black eyes still bore witness to their encounter with Tearaway's fist in Mantua.

Once again I was fast asleep, and this time he grabbed me round the waist, threw me over his shoulder and dashed out, with me only in my night-dress, towards the watch fire, into which he was obviously intending to throw me. I woke up, and although I didn't quite know what was happening, I realised the danger I was in, finding myself half-naked and Tearaway rushing with me towards the fire, so naturally I started screaming blue murder. That woke the whole camp, even the colonel came dashing out of his tent, clutching his halberd, followed by other officers, who assumed there was some kind of brawl they would have to sort out, since there was no danger of enemy attack. What they witnessed was a comic turn, a slapstick farce, which must have been very amusing to watch. The guard managed to intercept Tearaway before he could deposit his loudly protesting burden in the fire. When they realised it was Courage and that I was as good as naked, the corporal had the decency to wrap his cloak round me. By that time we were surrounded by officers of all ranks, who were killing themselves with

laughter. Not only the colonel was there, but also the lieutenant-colonel whose threats had brought about the recent reconciliation between me and Tearaway.

When Tearaway had come back to his senses (or pretended to, I honestly can't say what was going on inside his head) the colonel asked him what this nonsense was about. He replied that he had dreamt I had poisonous snakes all over me and thought the best way to free me from them was to throw me into water or onto a fire. That was why he had picked me up and run out with me, as everyone had seen, and which he now regretted from the bottom of his heart. Both the colonel and the lieutenant-colonel, who had supported him at Mantua, shook their heads at this and, since everyone had laughed their fill by then, ordered him to be taken to the provost-marshal to be locked up; me they sent back to my tent to continue my interrupted sleep.

The proceedings started the next morning and, as these things didn't take as long during war as in some places in peacetime, were expected to be concluded the same day. Everyone knew I wasn't Tearaway's wife, only his mistress, so we didn't have to go to an ecclesiastical court to get a divorce, but I wanted a legal separation because I no longer felt I could sleep safely in my bed. In this I had the support of all the assessors, who agreed that this would be sufficient grounds for dissolving a genuine marriage. The lieutenant-colonel, who had taken his side in Mantua, was now on mine, along with the rest of the regiment. Once I had produced my written contract, with the terms on which we had agreed to live

together until such time as we married, added to the fact that I would go in fear of my life if I were married to him, which you may be sure I made the most of, the court decided that, on payment of a fine, we should separate as soon as we had come to agreement on the division of what we had jointly earned through our business dealings. This, I replied, went against our agreement, added to which, since he had been with me or, to put it plainly, since I had taken him on and started up my canteen, Tearaway had squandered more than he had brought in, as the whole regiment could testify. The court finally decreed that if, taking all these factors into account, we could not come to an amicable agreement, the regiment would assess the situation and impose an apportionment.

I was more than happy with this, and Tearaway was more than happy to be fobbed off with a small settlement. Since coming to Austria our profits had gone down and I had accordingly been less liberal towards him and the other servants than in Italy, so that it looked as if we were having to tighten our belts. This made the nitwit assume my money was running out and I had nowhere near as much as, unknown to him, I actually had. And quite right too, for he didn't know why I was so determined to keep it hidden from him, either.

At about that time, Simplicius, the regiment of dragoons in which you learnt the rudiments of the soldier's trade in Soest was reinforced with a number of young lads who had served the officers of the infantry regiments and were now old enough to join

the ranks, but didn't want to become musketeers. This was a good opportunity for Tearaway and made him even more willing to come to a reasonable settlement with me. I gave him my best horse, together with saddle and bridle, one hundred ducats in cash and the dozen cavalry jerkins he had stolen in Italy at my instigation, for we hadn't yet found an opportunity of disposing of them. One condition was that he had to buy my familiar spirit from me for one crown, which he did. That, then, was the way I got rid of Tearaway and how I provided for him. And soon you'll hear of the choice present with which I rewarded you for your stupidity at the spa. But first, be patient a while longer and hear how Tearaway got on with the spirit in the glass.

As soon as he took possession of it he began to get all kinds of silly ideas. He only had to look at a man who had never done him the least harm to feel like wading into him. And he came out on top in all his duels. He could find hidden treasure and lots of other kinds of secret things I don't need to go into here. Once he had learnt what a dangerous object he was carrying round with him, however, he tried to get rid of it. He couldn't sell it because it had already reached its lowest price. He thought he could give it back and saddle me with it, so he threw it down at my feet at the general review before we marched on Regensburg. I didn't pick it up but just laughed in his face, and with good reason. When Tearaway got to his quarters he found it was back in his kit-bag. I was told he chucked the thing in the Danube several times, but always found it in his bag again

until he threw it in a baker's oven and got rid of it that way.

I must confess I didn't feel entirely happy while Tearaway was going round like this. I was afraid he might complain about my having sold him the glass, which could easily lead to me being put on trial as a witch. So I sold everything I had, paid off my servants and headed with my foster-mother for Passau, where I intended to stay, living on the money I had saved up, until the war was over.

Chapter 23

How Courage lost another husband and what she did next.

Things didn't work out as well in Passau as I imagined. The town was too priest-ridden and too pious. I would rather have seen some soldiers instead of all the nuns, some courtiers instead of all the monks. But I stayed there because at that time not only Bohemia, but most of the provinces of Germany had been overrun by the wars. Seeing that everyone in the town appeared to be God-fearing, I conformed, if only outwardly. What is more, my Bohemian foster-mother had the good fortune to go the way of all flesh in this devout place in the odour of godliness. I gave her a more splendid funeral than if she had died at St. James's Gate in Prague. I took it as an omen of misfortune to come, for now I had no one at all whom I could trust to look after me and mine. Although the town was not to blame, I hated it as the place that had taken my nurse, foster-mother and best friend from me. Nevertheless I stuck it out there until I heard that Wallenstein had captured Prague and brought it back under the emperor's rule. When that news came, and because the Swedes had the upper hand in Munich and the whole of Bavaria, and people in Passau were very much afraid of them, I returned to Prague, where I had deposited most of my money anyway.

I had hardly settled down there and started to enjoy all the money and possessions I had amassed in this large and, as I thought, very safe city when the Saxons under Arnim defeated the imperial forces at Liegnitz. He captured fifty-three companies there and threatened Prague. However, His Majesty King Ferdinand III, who at the time was besieging Regensburg, sent Count Gallas to help us and he forced the enemy to withdraw not only from Prague, but from the whole of Bohemia.

That made me realise that, for all their ramparts, towers, walls and moats, the big, powerful cities were incapable of protecting me and my possessions against the might of armies that camped out in the open, in huts and tents, moving from place to place. I therefore decided I should try to attach myself to one of those armies again.

At that time I was still quite pretty and attractive, even if by no means as beautiful as I had been a few years earlier, and with experience and a bit of hard work I soon hooked another captain, from Count Gallas's reinforcements this time. He married me, as if the city of Prague felt it was duty bound to supply me with husbands, and with captains at that. Our wedding was an aristocratic affair, but hardly was it over than the order came to join the imperial army, which had united with the forces of the Spanish Ferdinand, the Cardinal-Infante, taken Donauwörth and was now besieging Nördlingen. The Duke of Weimar and Gustavus Horn arrived to relieve the city and a bloody battle ensued, the course of which, and the changes it brought, will never be forgotten.

Although fortune was on our side, it brought me misfortune, robbing me in the very first attack of a husband who had barely had time to demonstrate his love for me. Moreover I didn't get the opportunity, as I had in previous battles, of taking booty myself, at first because of others who were ahead of me and then because of my husband's premature death. These seemed to me portents of my future decline and brought on the first bout of melancholy I had ever experienced.

After this encounter, our victorious army was divided up into a number of detachments to recover the German provinces which, however, they ravaged rather than secured. With the regiment in which my husband had served I followed the corps that occupied the land around Lake Constance and Württemberg. Once there, I took the opportunity of visiting the region my first captain (also supplied by Prague, but taken away by Hoya) came from and of seeing the estate he had left me. I liked the area so well that I decided to settle in the imperial town of Offenburg, especially as the enemies of the House of Austria had been scattered far and wide, across the Rhine and God knows where, so that I thought nothing was more certain than that I could spend the rest of my life safe and sound in that imperial city. I didn't want to go back to the wars, anyway. After the infamous battle of Nördlingen everywhere had been picked so clean I suspected the imperial forces would find little in the way of decent booty.

So I started to set myself up as a farmer. I bought cattle and land, I hired labourers and dairymaids, in

short I behaved as if the battle had put a final end to the wars or a peace treaty had been agreed. I withdrew all the money I had deposited in Prague and other large cities and used most of it to finance this. So you see, Simplicius, by my reckoning we both became fools at the same time, I in Swabia and you in Hanau. I squandered my money and you your youth. You got caught up in a foul war while I deluded myself into believing in a peace that was to be a long time coming. Before I was even properly settled in, there were armies marching through and being billeted on me for winter quarters, which still did nothing to reduce the contributions that were levied. And if I hadn't had a tidy sum of money, and both sense and cunning enough to conceal the fact, I would have been down to my last penny in no time at all. I had no one in the town I could look to for a helping hand, not even my former husband's friends because they were the ones who would have inherited his estate if, as they put it, some ill wind hadn't blown me along. For that reason I was assessed for pretty hefty financial contributions, though that didn't make them quarter any fewer soldiers on me. I was treated like all widows who are alone in the world.

I'm not complaining, though, nor am I looking for comfort, help or sympathy from you. I'm just telling you to let you know that it didn't bother me much, indeed, I was pleased when we had a regiment quartered on us for the winter. As soon as they appeared I started making eyes at the officers. Day and night was one long orgy of eating and drinking, whoring

and buggery. I danced to their tune so that they, once they had taken the bait, had to dance to mine, and when they left their winter quarters they took very little money with them. I had plenty of tricks up my sleeve to get them to part with their cash and snapped my fingers at those who said anything against me. I always had a few maids who were no better than I was, but I went about things in such a canny and discreet way that even the authorities, bless them! had more reason to turn a blind eye than to punish me, especially since as long as I was there plying my trade their wives and daughters were less likely to be seduced from the path of virtue.

I led this life for several years before I fell victim to one of its occupational hazards. That happened at the beginning of summer, when the armies went back into the field. Every year at that point I drew up a balance sheet of my winter campaign and generally found that my income had exceeded the cost of operations. But, Simplicius, the time has come for me to tell you how I took you for a ride. From now on, therefore, I'm going to talk to the readers, but you can listen if you like, and interrupt me if you think I'm lying.

Chapter 24

How Simplicissimus and Courage got to know – and deceived – each other.

We had to accommodate a large garrison in the town when the forces of the Elector of Bavaria and the French with their Weimar allies were at each others' throats on the Swabian border, and most of the officers among them were very partial to what I had to offer, at a price of course. But I rather overdid it, both out of lust for the money I made and the insatiable lust of my own flesh, and went with almost anyone who was willing, with the result that I got what by rights I should have had twelve or fifteen years earlier, namely the French disease (if you'll excuse my mentioning it). It blossomed and started to adorn me with rubies just as the merry month of May was bestrewing the ground with pretty little flowers. Fortunately my finances were still in a healthy enough state for me to be able to afford a cure, for which I went to a town on Lake Constance. My doctor told me, however, that my blood was not quite cleansed yet, and recommended taking the waters at Griesbach to complete the cure. I followed his advice and equipped myself with a fine carriage and pair, a servant and a maid who was cut from the same cloth as myself, except that she had not yet been saddled with the aforementioned charming disease.

I had scarcely been at the spa a week when Herr

Simplicissimus made my acquaintance, for birds of a feather flock together, as the devil said to the charcoal-burner. I put on aristocratic airs, and since Simplicissimus went round in such an extravagant get-up and had lots of servants, I assumed he was a nobleman and wondered whether I might succeed in snaring him by the horns, as I had done so often before, and obtain yet another husband. He duly obliged and came sailing along under full canvas to take anchor in the dangerous harbour of my insatiable desires, and I drew him on just as Circe did the wandering Ulysses. I was already beginning to think I had managed to tie him down when the perverse wretch broke free by means of a hoax which showed his ingratitude, made me a laughing stock and did him no good either.

By shooting a blank cartridge while I was on the lavatory and then spraying me with a syringe full of blood he made me believe I had been wounded, so that not only the surgeon who came to bandage me, but almost everyone else in the spa had a good view of all my charms. It was the talk of the town, everyone was laughing at me and mocking me until I could stand it no more and left Griesbach and its waters before I had completed the treatment.

In chapter six of the fifth book of his memoirs, that idiot Simplicissimus calls me a lady of easy virtue and says I was 'more nubile than noble'. I admit both charges. But if he had been noble, or had any good in him at all, he would not have got involved with the shameless hussy he believed me to be and certainly not trumpeted his own dishonour and my

disgrace to the whole world. What credit do you think it does the poor fool, dear reader, to tell everyone that he, to quote his own words, 'very quickly obtained entry both to her salon and to any other pleasures' he could desire from a woman whose 'easy virtue soon disgusted' him. And one who had not completely recovered from the pox into the bargain! Surely he would have done better to keep quiet about it? But that's the way it is with these stallions, they're like animals, they'll go after anything female, or like huntsmen who'll shoot any game. He describes me as 'sleek and shapely'. Let me tell him that by then I had less than one seventeenth of my original beauty and was already resorting to all kinds of creams and lotions, a large amount of which he himself licked off me.

But enough of that. Some fools will never learn. Just hear how I eventually paid him back. I left Griesbach seething with rage and determined to have my revenge for the way he had scorned me and made a public mockery of me. My maid had been just as hard at it as I had but, not knowing how to stop a bit of fun going too far, the silly goose let herself be lumbered with a baby boy, which she gave birth to on my farm outside Offenburg. I was determined she would get it called Simplicissimus, even though he had never touched her. As soon as I heard Simplicissimus had married a peasant girl, I made my servant wean her baby, had it provided with fine linen, even silk swaddling clothes and coverlets, to make the deception all the more convincing, and got her and my dairyman to take it to his house at night and

leave it on his doorstep with a note to the effect that he was the father and I the mother. You can't imagine how much I enjoyed this deception, especially when I heard of the heavy fine the authorities had imposed on him and the way his wife made his life a misery with her constant harping on about it. It also pleased me that I managed to persuade my simple-minded lover his barren mistress had given birth. If I had been capable of that I would have done so in my youth and not waited for the approach of old age. I was getting on for forty by then and didn't deserve such a malicious brute as Simplicissimus.

Chapter 25

Courage is caught in the act and expelled from the town.

I suppose I ought to stop at this point, since I have made it quite clear what kind of lady it was Simplicissimus boasted he had outsmarted. However, just as what I have already recounted will doubtless bring him nothing but shame and mockery, the rest of my tale will hardly redound to his honour either.

Behind my house in Offenburg I had a garden with fruit, herbs and flowers which I was proud of and which was the equal of any in the town. Next door lived an old adulterer who had a wife much older than him. He very quickly realised what kind of woman I was, and I was not averse to accepting his services in times of need. We often met in my garden to pluck flowers together, so to speak. We had to be quick about it so that his jealous wife did not suspect what was going on, but we assumed we were safer in the garden than anywhere else, with all the leaves and covered alleyways to conceal our sins from the eyes of men, if not from the eyes of God.

Right-minded people may well believe the cup of our iniquity was full to overflowing, or that God in His goodness had decided to teach us a lesson to bring us to repentance. However that may be, one day at the beginning of September we had arranged a rendezvous for the evening, which was mild, under a pear tree in my garden. That very same evening

two musketeers from the garrison had decided to appropriate a share of my pears, and they were up the tree picking fruit before the old man and I appeared in the garden. It was fairly dark, and my lover was there first, but I arrived soon after and we immediately got down to business, as we had so often before. Then, damn me! I don't know quite how it happened, but one of the soldiers must have shifted his position in the tree, to get a better view of the performance we were putting on, and did it so carelessly that he dropped all the pears he had picked. As they thudded to the ground the old man and I were convinced it was an earthquake, sent by God to turn us away from our sins. At least that was what we said to each other as we separated in fright. The musketeers in the tree couldn't help laughing, which terrified us even more, especially the old man, who thought it was a ghost come to haunt us, so we each went back to the safety of our homes.

The next day I was in the market square when I heard a musketeer shout, 'I know something.'

'What is it you know?' another asked at the top of his voice.

'There was an earthquake of pears last night!' the first replied.

This shouting got louder as it went on. I immediately realised what was I was in for and blushed, even though I didn't usually get embarrassed. I knew at once I was going to have to run the gauntlet, but I had no idea it was going to be as bad as it turned out to be. When even the street urchins knew about our affair, the authorities had no choice but to arrest us

and lock us up in separate cells. However, we both lied like the devil, even though they threatened to torture us.

They made an inventory of all my possessions and impounded them. My servants were interrogated under oath as well, but their statements were contradictory as not all of them were aware of my loose ways and the maids remained loyal. Eventually it was I who gave the game away. The mayor often came to see me in prison, calling me cousin and putting on a great show of sympathy, whereas in fact he loved justice more than his so-called cousin. He told me, in feigned confidence, that my aged lover had confessed to repeated acts of adultery with me, and without thinking I exclaimed, 'Well I hope the old arsehole gets a mouth full of shit, since he can't keep it shut!' and asked my supposed friend to help me out of the situation. Instead he gave me a sharp sermon, then opened the door and revealed a notary and witnesses who had listened to and written down everything we had said.

The proceedings were rather strange. Most of the aldermen were for having me tortured, to make me confess to more similar crimes. Then once my guilt had been established they could make me shorter by a head and rid the world of a useless burden, a sentence which was communicated to me in great detail. I defended myself by claiming they were less interested in seeing justice done and upholding the law than in confiscating my money and possessions. If they were going to be as strict as that with me, I went on, then there were many who were thought

respectable citizens who would accompany me to the block. I could prattle on as well as any lawyer and my speeches and objections were so sharp and so shrewd as to astonish the experts. The conclusion was that I had to leave the town for good, and as punishment I had to forfeit all my goods and property, including more than a thousand imperial thalers in cash. I was allowed my clothes and personal effects, apart from some jewels which one person or another pocketed. What could I do about it? If they had insisted on following the letter of the law, my sentence would have been worse. But it was wartime and the good burghers ('good burgheresses' I should have said) thanked the Lord the town had got rid of me in such a satisfactory fashion.

Chapter 26

Courage marries a musketeer; what happened when he left a pair of legs in a farmer's house.

At that time there were no imperial troops anywhere near that I could join. Therefore I thought I would go to the Weimar or Hessian armies, which were stationed in and around the valley of the Kinzig, to see if I could get another soldier as a husband. Alas, the first flush of my beauty had vanished, withered like a spring flower, and my recent misfortune and all the worries it caused had not improved my looks. I had also lost all my wealth, which often gets older women a man. I sold whatever I could of the clothes and jewellery I had been allowed to keep, bringing in two hundred crowns, and set off with just a boy as servant to seek my fortune wherever I could find it.

What I found was misfortune and more misfortune. Before I had even reached Schiltach we were taken by a party of musketeers from the Duke of Weimar's army who gave my boy a beating, took everything he had and then sent him packing, while I was dragged off to their quarters. I told them I was the wife of a soldier in the imperial army and that my husband had been killed at Freiburg im Breisgau, that I had been with my husband's people but was now on my way to my own home in Alsace. As I have already said, I was by no means as beautiful as I had been, but there was still enough there to make one of

the musketeers fall in love and want to marry me. What could I do? I preferred to grant this man what he asked for out of love, than to be compelled by force to give myself to the whole platoon. To cut a long story sort, I became the musketeer's wife even before the chaplain had married us.

My idea was to run a canteen, as I had with Tearaway, but I lacked the cash to set it up. I also missed my foster-mother and I soon came to the conclusion my new husband was much too dishonest and dissolute for a business like that. I did start to peddle tobacco and brandy, as if I could regain, halfpenny by halfpenny, the crowns I had so recently lost by the thousand. I hated having to go on foot, especially with a heavy pack to carry. Added to that, at times we were on short commons, something I had never even tried before, much less got used to. Eventually I managed to acquire a good mule, which could not only take a heavy load, but was also faster than many a horse. That made two asses I had to provide for, but I looked after them as well as I could to make sure each was capable of serving me to the best of his ability. Now that I and my baggage were carried I found the life more bearable and put up with it until the beginning of May, when Mercy, the Bavarian general, dealt us some telling blows at Mergentheim. But before I go on to the next chapter in the story of my life, I must tell you an amusing little to-do my husband unwittingly caused while we were still stationed in the Kinzig valley.

At his officer's instigation, and with my approval, he dressed himself up in old rags, put an axe over his

shoulder and set off, disguised as a poor, homeless carpenter, to carry letters regarding the concentration of forces or other plans to particular places we could not otherwise reach because of the danger from imperial patrols. It was freezing cold and I did feel sorry for the poor thing as he went off, but it had to be because there was a tidy sum of money to be earned, and he did come home safe and sound.

On one of the byways, which he knew very well, he came across a dead body. It must have been that of an officer as it had a pair of scarlet breeches with silver braid such as officers wore at the time; the jerkin, boots and spurs were of similar quality. He examined his find, but couldn't tell how the officer had died. Nor did he care whether he had frozen to death or been killed by the Black Forest peasants, it was the jerkin that attracted him and the jerkin he was going to have. And once he had that, he fancied the breeches to go with it. To get those he had to remove the boots first, which he did, but when he tried to pull the breeches down they wouldn't come off. The corpse was already decaying and the moisture oozing out below the knees, where the garters are tied, had seeped into both lining and material, so that breeches and flesh were frozen together as hard as stone. He was determined not to leave the breeches behind and the idiot was in such a hurry the only way he could think of getting them was to chop off the legs at the knees and pack the whole lot into his bundle. Thus loaded down, he found a farmer who let him bed down for the night by the warm stove.

Unfortunately for the farmer, one of his cows calved during the night and because it was so cold the dairymaid brought the calf into the warm room and put it on half a bundle of straw by the stove, next to my husband. By the time dawn was approaching my husband's new trousers had thawed from the legs, so he took off some of his rags, replacing them with the jerkin and trousers (which he turned inside out), left his old clothes and the legs beside the calf, climbed out of the window and came home safe and sound.

Early in the morning the maid came in to see to the calf. When she noticed the two legs lying there with my husband's rags and leather carpenter's apron, but no sign of my husband, she started screaming blue murder. She ran out, slamming the door behind her as if the devil himself were at her heels. She made such a noise she woke not only the farmer but the whole neighbourhood, who assumed a party of soldiers had arrived. Some immediately ran off, while others made ready to defend themselves.

The maid, trembling with fear and terror, told the farmer the reason for her screams, namely that the new-born calf had eaten up the poor carpenter who had spent the night with them, leaving nothing but his feet. And it had made such a face at her she was sure if she had not taken to her heels at once it would have pounced on her. The farmer was going to kill the calf with his boar-spear, but his wife refused to let him risk even going into the room, and insisted he ask the village mayor for help. The latter rang the alarm to collect the whole community so they could

storm the house in a body and exterminate this man-eater before it grew into a cow.

It was a hilarious sight to see the farmer's wife handing her children out of the bedroom window one by one, followed by pieces of furniture, while the men were peering in through the living-room windows to see the dreadful monster and the pair of half-legs beside it, proof enough of its savage ferocity. The mayor ordered them to storm the house and destroy this minotaur in the making, but everyone held back. They all said, 'But what about my wife and children if I get killed?' Finally they followed the advice of one of the old farmers and decided to burn both house and calf, whose mother, they assumed, must have been covered by a dragon, and compensate the farmer from the public purse to help him build a replacement. They then set about it with gusto, telling each other to imagine it was the thieving soldiery that had burnt it down.

Since this happened to him by chance, it made me think my husband might be the kind of man who enjoyed good luck in such escapades. I wondered what he would be capable of if I trained him like Tearaway, but the ninny turned out to be a useless ass. Anyway, he was killed soon afterwards in the battle of Mergentheim, because he just didn't know how to look after himself.

Chapter 27

When Courage's husband is killed in battle she escapes on her mule and joins a band of gypsies; she gets more than she bargained for when she steals some jewels.

After the battle I escaped on my excellent mule, discarding my tent and the less important items of baggage and retiring with the survivors, including Marshal Turenne himself, as far as Kassel. Since my husband was dead and there was no one else I wanted to team up with or who would take me on, I joined the gypsies who were with Königsmark's troops in the main Swedish army, which had joined us at Wartburg. Among them I met an ex-lieutenant, who immediately recognised my virtues – my light fingers, my heavy purse and other qualities these people value – and immediately made me his wife. One advantage was that I no longer needed to use creams and lotions to make my skin lovely and white, since both my new station in life and my husband demanded a complexion as dark as the devil's own. I started smearing myself so thickly with goose fat, louse repellent and other ointments and pomades that very soon I looked as satanic as if I had been born in the middle of Egypt. I often had to laugh at myself and marvelled at the transformation in me. Nevertheless gypsy life suited me so well I wouldn't have changed it, not even to be a colonel's lady. In a short time one of the gypsy grandmothers had

taught me how to tell fortunes, and I could already lie and steal, although the gypsies had some tricks of their own I hadn't come across. But why go on about it? In no time at all I had mastered everything so perfectly you would have taken me for the leader of all gypsy women.

However, I wasn't so clever that I escaped everywhere unscathed, even though I did bring home more for my husband to enjoy than ten others. Just listen to what happened to me once!

During our march we spent a night and a day not far from a friendly town where everyone could go to buy whatever they liked. I also went, though spending money was not what I had in mind, the only acquisitions I intended to make being those my five light fingers or some other ploy could procure for me.

I had not gone far into the town when a young noblewoman sent her maid to ask me to come and tell her fortune. The messenger herself went on at great length about how her mistress's lover had discarded her for another and I made excellent use of the information. The fortune I told was so accurate, the poor abandoned maiden said, it put all the almanacs, even the prophets and all their prophecies in the shade. Then she poured out her heart to me and asked if I couldn't put a spell on her fickle lover to bring him back onto the straight and narrow.

'Certainly I can, my lady,' I replied. 'I know one that will have him back at your beck and call even if he has a breast-plate as strong as Goliath's.'

That was exactly what the poor besotted fool

wanted to hear, and she wanted me to set to work at once. I told her we had to be alone and undisturbed, so she sent her maid away, telling her to be sure not to breathe a word to anyone. I went with the lady to her bedroom where I asked her to give me a black veil she had worn when she was in mourning for her father, a pair of earrings, a valuable necklace she was wearing, her belt and her favourite ring. When I had the jewels I tied them up in the veil, making several knots and muttering some mumbo-jumbo as I did so, and put them in the lovesick lady's bed. After that I said we had to go down to the cellar, where I persuaded her to undress down to her shift. While she was doing that, I drew some strange symbols on the lid of a large wine cask, then pulled out the spigot and told the lady to block up the hole with her finger while I put the finishing touches to the spell upstairs with the spigot. Once I had the simpleton well and truly stuck there, I went and fetched the jewels and set off out of the town as fast as my legs would carry me.

Unfortunately, either this devout, credulous, lovelorn maiden and her possessions enjoyed heaven's special protection, or fate did not intend me to have the jewels. Before I reached the safety of our camp, I was stopped by a noble officer from the town garrison who demanded them from me. I denied having them, but he beat the truth – and the jewels – out of me. He ordered his servant to dismount and search me, and when I resisted with my fearsome gypsy knife he drew his sword and belaboured me so hard about the head, arms, shoulders and back that I spent the next

JOHANN JAKOB CHRISTOFFEL VON GRIMMELSHAUSEN

four weeks rubbing on ointment before the bruising
went away. I do believe the fiend would have kept on
beating me to this very hour if I hadn't dropped my
loot at his feet. And that was the reward I got for
my invention and the clever deception.

Chapter 28

Courage and her band come to a village where a fair is being held; the gypsies organise a spectacle of their own so their women can steal the food.

Not long after this thrashing our gypsy horde left Königsmark's troops and went back to the main Swedish army, which Torstenson had led into Bohemia, where the two generals joined forces. Not only did I and my mule remain with the army until the peace treaty was concluded but, not thinking I could give up my thieving way of life, I stayed with the gypsies even after peace had been established. And since I can see that my scribe still has one blank sheet of paper left, as a parting gift I will finish off by telling you a scheme I thought up and carried out not long ago, to give you an idea of the kind of thing I get up to and how well I fit in with the gypsies.

Once, when we were in Lorraine, we came towards evening to a large village where a fair was being held. Because of this, and because, with men and women, children and horses, we were quite a large company, we were initially refused permission to camp there for the night. But my husband, who pretended to be the lieutenant-colonel, gave his word as a nobleman that he would compensate them for any damage or theft out of his own pocket and visit the full force of the law on the perpetrator into the bargain. After a

good deal of trouble he managed to persuade them with this argument to let us stay there.

The whole village was filled with the smell of festive roasting and baking, which immediately aroused my appetite – and annoyance at the idea of the villagers eating it all themselves. Straight away I thought up a ploy by which we could help ourselves to the food. I got one of our young lads to shoot a hen outside the inn. It wasn't long before a serious complaint was being made to my husband. He pretended to be extremely angry and had one of our number sound his trumpet to gather the band together. While this was being done and villagers and gypsies were gathering in the square, I told some of our band my plan in our thieves' cant and said every woman should be ready to grab what she could.

After a short court-martial, my husband sentenced the accused to death by hanging because he had ignored his commander's orders. At this, word went round the village like wildfire that the lieutenant-colonel was going to have a gypsy executed just for killing a hen. Some thought the sentence too strict, others praised us for maintaining such discipline. One of our men had to play the executioner and bound the condemned man's hands behind his back. A young gypsy woman pretended to be his wife, borrowed three children and came running into the square with them. She pleaded for her husband's life, begging the 'lieutenant-colonel' to have a thought for the children and crying and sobbing as if she were in despair. My husband however,

now that he reckoned the whole village had gathered to see the execution, refused even to listen and had the malefactor led away towards a wood to carry out the sentence. And almost all the village, young and old, men and women, maids and servants, even babes in arms went out with us. The young gypsy woman and her three borrowed children were still moaning, wailing and pleading, and when we came to the tree where the foul assassin was to be strung up, she put on such a heartrending performance that first the farmers' wives and then even the farmers themselves started to plead for the condemned man and did not let up until my husband gave way to their entreaties and reprieved him.

While we were putting on this comedy outside the village, our women were in the village, thieving for all they were worth. And since they not only cleared out the spits and cooking pots, but also picked up certain more valuable items during their raid, they left the village and came out towards us, pretending to be trying to provoke the men to rebel against me and my husband because he was going to execute such a fine man and make his wife a poor lonesome widow and three innocent little children orphans, all for the sake of one measly chicken. But in our language they said they had picked up some nice things and we should clear off with them before the villagers realised they had been taken. So I shouted at the ones who were pretending to be rebellious to run off into the woods, away from the village. Then my husband and all those who were with him drew their swords and set off after them. They even fired their

muskets, and the others replied in kind, though neither aimed to hit anyone.

The villagers, horrified at the prospect of bloodshed, went back to their homes, but we carried on chasing the others deep into the forest, where we knew every path and track, shooting all the time. We marched the whole night and in the morning not only shared out the spoils, but also split up into several smaller groups, thus avoiding any danger of being caught by the villagers.

By now I have travelled round almost every corner of Europe several times with these people and the number of schemes and tricks I have both thought up and carried out is so great that it would take a whole ream of paper, if not more, to write them all down. That is why I am always surprised that people put up with us in these countries, since we are of no use to God nor man and make our living by lying, cheating and stealing, to the detriment of both the country folk and the great lords, whose game we eat. But I'd better stop there before I blacken our name too much. I think I have told you enough about the kind of woman Simplicissimus boasted about sleeping with in Griesbach to make him a permanent laughing stock. I should imagine it quite often happened that he fooled himself into thinking he was having a beautiful girl when in fact he was making love to some poxy whore or even a witch whose favours he shared with the devil.

A note by the author

All you chaste young men, honest widows and you married men too, who have so far guarded against these dangerous Chimaeras, avoided these terrible Medusas, stopped your ears at these damned Sirens and rejected these insatiable Danaides, continue to resist the lures of these she-wolves. For one thing is certain: the only thing you can expect from consorting with whores is all kinds of defilement, shame, scorn, poverty, misery and, what is worst of all, a bad conscience. It is only when it is too late that you realise what you have had, how foul, disgusting, louse-ridden and scabby they are, with stinking breath and stinking bodies, full of the pox inside and covered with pustules outside, so that eventually you are covered with the same shameful eruption and regret comes far too late.

Simplicissimus – Johann Jakob Grimmelshausen

Mike Mitchell's superb new translation replaces S. Goodrich's 1912 version and allows us to enjoy more fully one of the great masterpieces of European literature and the first German bestselling novel.

"It is the rarest kind of monument to life and literature, for it has survived almost three centuries and will survive many more. It is a story of the most basic kind of grandeur – gaudy, wild, raw, amusing, rollicking and ragged, boiling with life, on intimate terms with death and evil – but in the end, contrite and fully tired of a world wasting itself in blood, pillage and lust, but immortal in the miserable splendour of its sins."

Thomas Mann

"Simplicissimus is the eternal innocent, the simple-minded survivor, and we follow him from a childhood in which he loses his parents to the casual atrocities of occupying troops, through his own soldiering adventures, and up to his final vocation as a hermit alone on an island. It is Rabelasian in some respects, but more down to earth and melancholy."

Phil Baker in The Sunday Times

£10.99/$17.99 ISBN 1 873982 78 X 434pp B Format

The Golem – Gustav Meyrink

"Gustav Meyrink uses this legend in a dream-like setting on the Other Side of the Mirror and he has invested it with a horror so palpable that it has remained in my memory all these years."
Jorge Luis Borges

"A remarkable work of horror, half-way between *Dr Jekyll and Mr Hyde* and *Frankenstein*."
The Observer

"A superbly atmospheric story set in the old Prague ghetto featuring The Golem, a kind of rabbinical Frankenstein's monster, which manifests every 33 years in a room without a door. Stranger still, it seems to have the same face as the narrator. Made into a film in 1920, this extraordinary book combines the uncanny psychology of doppelganger stories with expressionism and more than a little melodrama . . . Meyrink's old Prague – like Dicken's London – is one of the great creations of city writing, an eerie, claustrophobic and fantastical underworld where anything can happen."
Phil Baker in The Sunday Times

£6.99 ISBN 1 873982 91 7 262pp B Format

The Angel of the West Window – Gustav Meyrink

"Dedalus has done everyone a favour and published *The Angel of the West Window*. The narrator believes he is becoming possessed by the spirit of his ancestor John Dee. The adventures of Dee and his disreputable colleague, an earless rogue called Edmund Kelley, form a rollicking 16th century variant on Butch Cassidy and the Sundance Kid as they con their way across Europe in a flurry of alchemy and conjured spirits. At one point, Kelley even persuades Dee that the success of an occult enterprise depends on his sleeping with Dee's wife. Past, present, and assorted supernatural dimensions become intertwined in this odd and thoroughly diverting tale."

Anne Billson in The Times

£9.99 ISBN 0 946626 65 0 421pp B Format

Walpurgisnacht – Gustav Meyrink

"It is 1917. Europe is torn apart by war, Russia in the grip of revolution, the Austro-Hungarian Empire on the brink of collapse. It is Walpurgisnacht, springtime pagan festival of unbridled desire. In this volcanic atmosphere, in a Prague of splendour and decay, the rabble prepare to storm the hilltop castle, and Dr Thaddaeus Halberd, once the court physician, mourns his lost youth. Phantasmagorical prose, energetically translated, marvellously evokes past and present, personal and political, a devastated world."

The Times

£6.99 ISBN 1 873982 50 X 192pp B Format

The Green Face – by Gustav Meyrink

"Of the volumes available to the English public, *The Green Face*, first published in 1916, is the most enjoyable. In an Amsterdam that very much resembles the Prague of *The Golem*, a stranger, Hauberisser, enters by chance a magician's shop. The name on the shop, he believes, is Chidher Green; inside, among several strange customers, he hears an old man, who says his name is Green, explain that, like the Wandering Jew, he has been on earth 'ever since the moon has been circling the heaven.' When Hauberisser catches sight of the old man's face, it makes him sick with horror. The face haunts him. The rest of the novel chronicles Hauberisser's quest for the elusive and horrible old man."

Alberto Manguel in The Observer

£7.99 ISBN 0 946626 92 8 246pp B Format

The Other Side – by Alfred Kubin

"Expressionist illustrator Kubin wrote this fascinating curio, his only literary work in 1908. A town name Pearl, assembled and presided over by the aptly named Patera, is the setting for his hallucinatory vision of a society founded on instinct over reason. Culminating apocalyptically – plagues of insects, mountain of corpses and orgies in the street – it is worth reading for its dizzying surrealism alone. Though ostensibly a Gothic macabre fantasy, it is tempting to read 'The Other Side' as a satire on the reactionary, idealist utopianism evident in German thought in the early twentieth century, highly prescient in its gloom, given later developments. The language often suggests Nietzsche. The inevitable collapse of Patera's creation is lent added horror by hindsight. Kubin's depiction of absurd bureaucracy is strongly reminiscent of Kafka's 'The Trial', and his flawed utopia, situated next to a settlement of supposed savages, brings to mind Huxley's 'Brave New World'; it precedes both novels, and this superb new translation could demonstrate its influence on subsequent modern literature."

Keiron Pim in Time Out

£9.99 ISBN 1 873982 69 0 249pp B Format